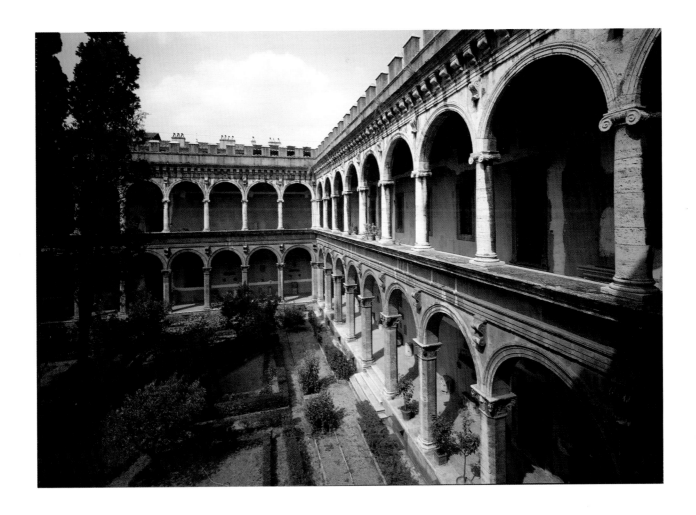

Masterpieces of Renaissance

and

Baroque Sculpture

from the

Palazzo Venezia, Rome

Georgia Museum of Art
October 5 – November 24, 1996

Shelley E. Zuraw

and

Maria Giulia Barberini

Pietro Cannata

Maria Letizia Casanova

GEORGIA MUSEUM OF ART · THE UNIVERSITY OF GEORGIA

Cover: Catalogue Number 15

Frontispiece: Courtyard of the "Palazzetto," Palazzo Venezia, Rome

© 1996 Georgia Museum of Art, University of Georgia

Design: Kudzu Graphics, Athens, Georgia
Body Copy: Monotype Apollo
Department of Publications: Bonnie Ramsey and Jennifer DePrima

Printed in an edition of 1,200 by Guest Printing Co., Athens, Georgia

This exhibition and catalogue benefit from the generous assistance of Mr. C. L. Morehead Jr. Additional support was provided by Mr. W. Newton Morris, Mrs. M. Smith Griffith, and by the National Italian American Foundation. Partial support for the exhibitions and programs for the Georgia Museum of Art is provided by the Georgia Council for the Arts through appropriations of the Georgia General Assembly and the National Endowment for the Arts. A portion of the museum's general operating support for this year has been provided through the Institute of Museum Services, a federal agency that offers general operating support to the nation's museums. Individuals, foundations, and corporations provide additional support through their gifts to the University of Georgia Foundation.

Library of Congress Cataloging-in-Publication Data

Museo del Palazzo di Venezia (Rome, Italy)

Masterpieces of Renaissance and Baroque Sculpture from the Palazzo Venezia, Rome : Georgia Museum of Art, October 5-November 24, 1996 / Shelley E. Zuraw and Maria Giulia Barberini, Pietro Cannata, Maria Letizia Casanova.

p. cm.

ISBN 0-915977-29-X

1. Sculpture, Italian—Exhibitions. 2. Sculpture, Renaissance—Italy—Exhibitions. 3. Sculpture, Baroque—Italy—Exhibitions. 4. Sculpture—Italy—Rome— Exhibitions. 5. Museo del Palazzo di Venezia (Rome, Italy)—Exhibitions. I. Zuraw, Shelley. II. Georgia Museum of Art. III. Title.

NB615.M88 1996

730'.945'07475818—DC20

96-36152

CIP

*This project was made possible through
the generous assistance of*

Mr. C. L. Morehead Jr.

and

Mr. W. Newton Morris

Mrs. M. Smith Griffith

Bob and Maxine Burton

The National Italian American Foundation
Washington D. C.

Table of Contents

Foreword

This exhibition was conceived with the aim of presenting some of the most important works of art from the Museum of the Palazzo Venezia. Exceptional both in terms of the quantity and the quality of its holdings, the Palazzo Venezia is unlike any other museum in Rome. One need only consider the various publications and exhibition catalogues produced by the museum in recent years to understand the breadth and depth of its collections, which extend into many areas of the visual arts: in addition to its famous paintings and sculptures, it also boasts remarkable ceramics, porcelain, silver, arms and armor, fabrics, and decorative art. Although, strictly speaking, it is not a comprehensive museum of decorative and applied arts, the Museum of the Palazzo Venezia does possess a vast collection encompassing all manner of artistic production.

Precisely because of the breadth of its collection, the Palazzo Venezia has always remained little-known relative to other Roman museums. Unlike many other museums, the Palazzo Venezia was not formed as a result of older collections that became public. Instead, it is a museum created in our own century under circumstances that are not at all typical in Italy. Despite this disadvantage, one may say that in the last twenty years much has occurred to make the Palazzo Venezia one of the most notable and important museums in Rome. And, indeed, the present exhibition confirms the museum's status: it demonstrates that its collections—or at least one part of them—may lay claim to well-deserved fame and historical significance. The undeniable masterpieces of Renaissance and Baroque sculpture presented here give an indication of the high quality of the museum's collection.

Although the works on display permit one to discern the essential features of a great era in art, sculpture is, as the entries in this catalogue suggest, an especially difficult field. In fact, to be understood well sculpture requires keen powers of observation, patience, and a real interest in art. But it can also bring the viewer profound satisfaction, both from the point of view of appreciating technical accomplishment and of sheer aesthetic enjoyment. I believe that one may find such satisfaction in this exhibition and in its accompanying catalogue. Indeed, there are extraordinary works on display: the reliefs by Mino da Fiesole, as well as pieces by Giambologna, Bernini, Algardi, Caffà, and Ferrata. Each one, by itself, is representative of the glories of Italian art in the Renaissance and the Baroque.

From this exhibition one may better appreciate what the museum of the Palazzo Venezia is and what it might become. Situated in the heart of Rome, in one of the most busy and vibrant spots of the city, this museum is a place that should always be given over, above all, to study and contemplation. The works that we have the honor of lending to the Georgia Museum of Art were, in fact, chosen with this principle in mind. These works are not merely ambassadors of Italian art in general, but emissaries of an attitude toward culture that the Palazzo Venezia and its museum embody.

Above all—or, perhaps one should say, exclusively—scholarly inquiry and the display of art seem to find their proper place in that historic building whose legacy is summarized in this catalogue. This is as it should be. Yet, the actual physical conditions of the museum are less than ideal in that the immense palace is also home

to offices of various kinds, and the latter limit gallery space. Nevertheless, the appreciation of art is an ideal worth pursuing, for dedication to culture is a value that serves not only Italy but the world as a whole.

One can hope that today, thanks to a new political and cultural climate not only in Italy but throughout the world, American visitors as well as our colleagues in the academic community may appreciate the significance of this exhibition: it exemplifies a kind of seriousness that we hope to maintain and, thereby, to improve not only our cultural institutions but also our endeavors in the realm of scholarship.

Claudio Strinati
SUPERINTENDENT OF FINE ARTS, ROME

Acknowledgements

INHERENT IN THE GIFT TO THE GEORGIA MUSEUM OF ART OF TWELVE SO-CALLED study paintings from the dispersal of the great Samuel H. Kress Collection has been the promise that these pictures would inspire research. And so they have, especially in the years since 1989, when exhibitions of Italian Renaissance maiolica, Venetian paintings of the Renaissance, Italian Renaissance and Baroque drawings, Baroque pictures from Bob Jones University, and a splendid collection of objects from the Fondazione Horne in Florence have been organized at the museum and traveled throughout the nation. The Kress Study Collection at the museum has provided the impetus for publication not only of these exhibitions' catalogues but also of occasional publications on devotional objects, on workshop practices of Italian artists, and of collections of essays written by graduate students at the University of Georgia.

Although sculpture has not been excluded from these exhibitions, it has not been the sole focus of any. Thus, it is fitting that, in the year of celebration attending the opening of its new building, the Georgia Museum of Art joins forces with Palazzo Venezia, to bring to the University of Georgia, and, indeed, for the first time to the United States, a select group of masterworks of Italian sculpture.

Such a collaboration is a singular honor for the staff of the museum and for the academic community at the University of Georgia, and it is with sincere gratitude to our colleagues that we present this exhibition and catalogue: Professor Claudio Strinati, whose own writings have added so much to the knowledge of Italian art, has been faithful in his support of this project, especially in its potential for scholarship; Professor Maria Letizia Casanova, likewise a scholar and champion of this exhibition, has given invaluable advice and assistance; and Dr. Maria Giulia Barberini, curator at the Palazzo Venezia, who acted as the on-site curator in Rome, has believed in the importance of bringing such an exhibition to the United States from the initial discussions of this project and has been a mainstay in seeing the project through to completion. We are especially thankful to all three for their contributions to this catalogue, in which their museum is so ably described and represented. Our gratitude is likewise extended to Pietro Cannata, who wrote several of the catalogue entries, as well as to the conservators and staff members of our sister institutions in Rome who provided the necessary technical and clerical assistance.

On this shore, we give thanks to the members of the staff of the Georgia Museum of Art for their professionalism and dedication on behalf of this memorable exhibition and its catalogue. In addition, such a project required financial resources that were outside the capabilities of the Georgia Museum of Art, and this exhibition would not have been possible without the generosity of C. L. Morehead Jr., who proves once again that this museum and university have no greater friend than he. He inspires us to excellence.

The museum is especially grateful to the National Italian American Foundation, which stepped forward with support for this project. We thank the Georgia Humanities Council for a program benefiting senior citizens. Members of the museum's Director's Circle, Mrs. M. Smith Griffith, Mr. W. Newton Morris, and Bob and Maxine Burton, to whom we express warm appreciation, provided partial funding

for this catalogue.

Finally, the curator of the exhibition, editor of this catalogue, and writer of one of the essays, Professor Shelley Zuraw has been unswerving in her pursuit of one goal: for two years, she has worked on this project, one for which all its audiences owe her abundant thanks.

<div align="right">

William U. Eiland
DIRECTOR OF THE GEORGIA MUSEUM OF ART

</div>

THE GENESIS AND HISTORY OF THIS EXHIBITION IS RECORDED MOST ACCUrately through the debts of gratitude owed so many people. The idea, born during a casual conversation at the Palazzo Venezia in the fall of 1994, was only brought to fruition due to the ceaseless labor, creative energy, and scholarly wisdom of Maria Giulia Barberini, curator at the Palazzo Venezia. My gratitude for her help, encouragement, and endless patience know no bounds. I would also like to thank Maria Letizia Casanova, director of the Palazzo Venezia, as well as Pietro Cannata and Silvano Germoni for their dedicated work preparing the exhibition and catalogue. At one time or another it seemed to me that each member of the staff at the Museo Nazionale del Palazzo di Venezia, to say nothing of those at the office of the *Soprintendenza delle Belle Arti* in Rome and the conservation lab at the Palazzo Barberini, was called on to help in this effort. We are all indebted to their generosity. I would also like to thank Professore Claudio Strinati, the superintendent of Fine Arts in Rome, without whose approval this extraordinary opportunity to exhibit twenty-two works of sculpture in Athens would never have succeeded.

This exhibition would not have been possible without the support and encouragement of Professor Irving Lavin of the Institute for Advanced Studies, Princeton. I would also like to thank Alan P. Darr, curator of European sculpture at the Detroit Institute of Arts, for his assistance in the early stages of this project. It is always a pleasure to acknowledge the patience and help of my friends. Throughout the summer, in both Rome and Florence, Jack Freiberg, Arthur Iorio, Andrew Ladis, Janet Smith, Gail Solberg, and Jeryldene Wood listened, read, and gave advice.

A great deal of the preparation for this exhibition was done while I was in Florence. This meant, of course, that the staff of the Georgia Museum of Art was required to do much of the day-to-day work without me, adding to their already considerable burdens. I am happy to acknowledge the enormous amount of energy that they contributed, individually and collectively, to this exhibition. I would like to recognize the contributions of Tiffanie P. Townsend, an art history graduate student at the University of Georgia. She has worked on this show almost as long as I have and, although her name appears only in the acknowledgements, her service pervades the whole. Finally, I owe a great debt to Dr. William U. Eiland, director of the Georgia Museum of Art. From the very beginning, he believed that this exhibition could become a reality and his efforts on its behalf made it come true.

<div align="right">

Shelley E. Zuraw
CURATOR
ASSISTANT PROFESSOR OF ART HISTORY,
UNIVERSITY OF GEORGIA

</div>

Il Palazzo di Venezia

THE PALAZZO DI SAN MARCO— subsequently called "di Venezia" because it served as the official residence of the ambassadors of the Most Serene Venetian Republic from the end of the sixteenth century—constitutes, without doubt, the central monument of the Roman fifteenth century, both for its architecture and its significance for the history of Roman urbanism (Fig. 1). Its exceptional role and its prominence arise from its location within a particular inhabited space: the region marking the extreme limits of the city in that period, that is, the area at the foot of the Capitoline Hill.

By means of an impressive series of works—construction of the palace and its garden, restoration of the basilica of San Marco, reordering the urban tract of the Via Flaminia (the modern-day Corso)—Paul II (1464-1471) established a new canon for the design of urban spaces in the Renaissance, a system that favored balance and harmony over the haphazard irregularity typical of the medieval city.

Initially intended as the deacon's residence at the basilica of San Marco to replace even older, more modest houses on the same site, the complex was undertaken in two phases. The first, represented by the construction of the cardinal's palace, includes the body of the building adjacent to the church, which extended half the length of the present facade on the modern Piazza Venezia. The second phase of construction concentrated on the actual papal palace, enlarging the building almost to the corner of the Via Papale (now the Via del Plebiscito), completing and regularizing the front, as well as constructing the great eastern tower (Fig. 2).

Pope Paul II's nephew, Cardinal Marco Barbo, who inherited the title of Cardinal of San Marco from his uncle in 1467, was responsible for the execution of the most important portions of the palace. Those minor parts left

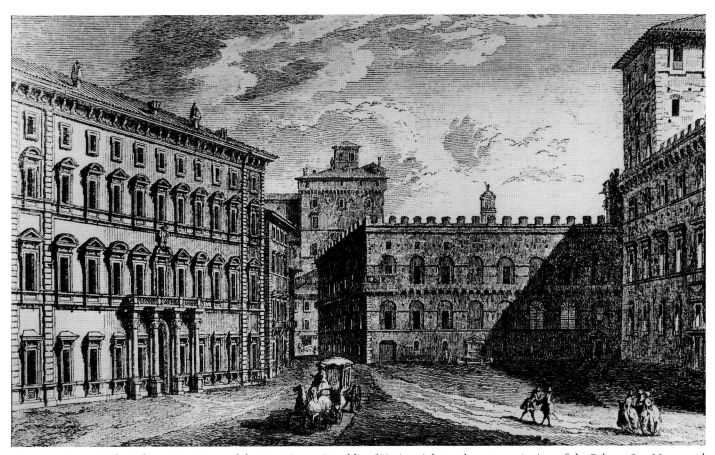

Figure 1 G. Vasi, *The Palazzo San Marco of the Most Serene Republic of Venice*, eighteenth century. A view of the Palazzo San Marco and the smaller adjoining "Palazzetto" of San Marco di Venezia as it appeared in eighteenth-century Rome. At the center rises the Tower of Paul III on the Campidoglio; to the left one sees the Palazzo Cenci-Bolognetti (later Torlonia), which was destroyed in 1900.

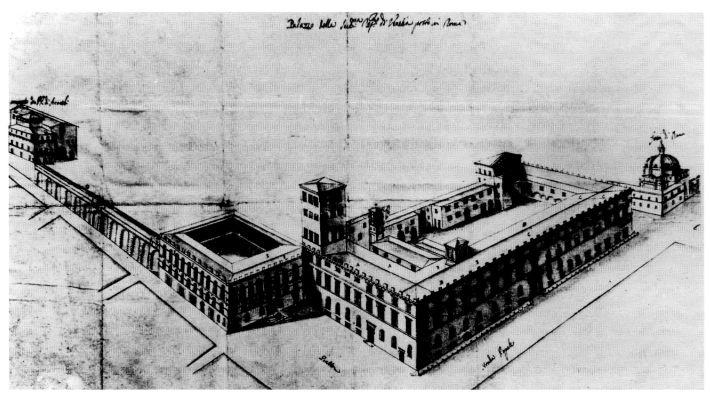

Figure 2
Bird's-eye view of the architectural complex of the Palazzo Venezia as it appeared in the seventeenth century.

incomplete at his death in 1491 were only finished at the end of the eighteenth century.

Paul II (1464-1471)

Descended from a great Venetian patrician family, Cardinal Pietro Barbo (the future Pope Paul II), nephew of Pope Eugenius IV, devoted himself to letters and to business with equal success. A fascinating study in contradictions, he embodied all the virtues as well as the defects of a Renaissance prince. Handsome and arrogant, at once sincerely religious and a devotee of astrology and palmistry, the cardinal of San Marco distinguished himself in the arts, especially as a collector. Over time, he amassed the richest collection of gems, coins, medals, and gold to be seen in Italy since the fall of the Roman Empire. During his papacy, Paul II acted as a vigorous politician and as a shrewd administrator, an observer who was aware of the needs of the more humble

classes but who also remained a strict guardian of the privileges and pomp of the absolute monarch.

The Cardinal's Palace

The palace which Cardinal Pietro Barbo set out to build directly behind "his" basilica was erected between 1455 and 1464. The Palazzo Barbo fit perfectly into the urban panorama of mid-century Rome. Rectangular and low, modestly surfaced in brick, and composed of a ground floor and a single residential floor above, the building incorporated a small, medieval tower, known as the "Torre della Biscia," that stood adjacent to the church. The palace possessed at least one door, asymmetrically placed on its western edge. The windows were an odd mixture of styles, some being "Gothic" and others using a more "modern" cross-shaped fenestration. The building was surmounted by a roof-terrace, a *belvedere*, literally "a beautiful view." Such terraces were

common in contemporary Roman domestic residences. The lack of a courtyard and a grand *piano nobile* demonstrates the difficulties encountered in this peculiar attempt to join elements associated with domestic architecture to a residence both physically and symbolically connected to an early Christian basilica. The body of this first palace extended into the *"platea nova Sancti Marci"* (today the Piazza Venezia), opposite the *"vetus"* or old piazza, located in front of the basilica. Its length was only half that of the present-day front, ending where today one finds the left wall of the Albertian vestibule.

There is a complete lack of information regarding the architect of the Palazzo Barbo. Attempts to attribute the work either to Francesco del Borgo or to Bernardo Rossellino have remained purely hypothetical. Although Francesco dal Borgo was involved in later work on the papal building, and although Bernardo Rossellino, architect of Nicholas V and future creator of the city of Pienza, was active in Rome until 1454, no concrete evidence for the direct involvement of either artist exists.

The Garden of San Marco

Alongside the Barbo palace and ideologically related to it is the *"viridarium"* or garden of San Marco (Fig. 3, frontispiece). Probably begun in 1464, the addition of this garden can be compared to other great Renaissance complexes which were also conceived with closely connected gardens. The two most famous parallels are the palaces of Pius II at Pienza and Federico da Montefeltro at Urbino. Despite such parallels, however, Pietro Barbo's garden represents an absolutely original solution to the problem of the relationship between

interior and exterior spaces. This garden is not the result of space carved from the body of the building itself, as at Urbino; nor is it simply a logical extension of the building, as at Pienza, where the garden is firmly connected to the house by a portico. Instead, it is a unique and separate space.

Located at the southeastern corner of the palace, the enclosed space of the garden served as a scenographic background to the long straight stretch of the Via Lata along the axis of the Porta del Popolo. This *viridarium* appeared to be a totally artificial, independent building, lacking any structural relationship to the cardinal's palace. The garden was linked to the latter, however, by a bridge connecting the *belvedere* and the Biscia tower, which was eventually incorporated into a second, larger tower in 1470.

At the same time, in perfect accord with the rules of Renaissance architecture, the garden generated new urban spaces: the *"platea vetus"* and the *"platea nova."* These open spaces simultaneously screened the palace from the surrounding streets and buildings and served as the point of juncture that linked the palace complex with the rest of the city. Thus, the garden qualifies as the pivotal point in a new, rationally articulated balance between private and public spaces.

Slightly trapezoidal in outline, the garden was located on an embankment supported by walls 4.70 meters high at street level. Its sustaining walls were perforated by round arches and enlivened by strongly projecting cornices. Inside, a portico of superimposed orders, consisting of octagonal pilasters on the first level and columns on the second, surrounded a grassy space. A series of open arches completely enclosed the building and allowed

views from the outside of flowering plants and full-grown trees.

Classical architecture is the obvious stylistic inspiration for the enframing courtyard with its clear, superimposed levels of piers and columns. Other aspects of this construction can be associated with two distinct versions of the Renaissance architectural vocabulary. The first, developed for buildings in early fifteenth-century Tuscany, influenced structural elements at the *viridarium*. Specific models for the Roman forms can be traced to the Brunelleschian churches of San Lorenzo and Santo Spirito in Florence as well as the Palazzo Comunale of Montepulciano by Michelozzo. In contrast, the fluid freedom of invention throughout and the exuberant decoration of the capitals of the first order reveal the influence of Alberti's volumetric and spatial harmony, as exemplified by the arches lining the sides of the Tempio Malatestiano in Rimini, but this influence is mediated by the architecture of Rossellino at Pienza. Yet the entire work remains faithful to Roman tradition, with its stout proportions and severe shapes. This powerful local style conditioned building practices in Rome throughout the second half of the century.

The construction of the *viridarium* is assumed to have taken place between 1466 and 1470, at the same time, therefore, as the second phase of construction of the palace proper. But it rapidly lost its character as an "architectural enclosure;" already in 1537 the majority of the arches were being sealed. This process continued until the Venetian ambassadors had all of the arches closed at the end of the sixteenth century, at which point the *viridarium* was definitively transformed into the *palazzetto di San Marco* or the "little palace," as Paul II's

"place of delights" has been commonly known for the last 200 years (Fig. 4).

Finally, in 1911, the construction of the monument to Vittorio Emanuele II unfortunately made it necessary to move the entire *viridarium* to its present location between the Via degli Astalli and the Via di San Marco, thereby permanently altering the entire surrounding urban context.

The Papal Palace

Construction of the "*palatium apostolicum*," begun in 1464 just as Cardinal Barbo ascended to the papal throne as Paul II, provided a critical stimulus to the revitalization of the Capitoline area. This new building activity also contained an important ideological message. Erected beneath the Campidoglio, the most important civic site in Rome, literally the hill-sanctuary of communal freedom, the Church, as embodied in this papal palace, was reintegrated into the quotidian life of the city. This strategy of conciliation, of physical and political *rapprochement*, between the power of the Curia and the rights of private citizens, was intended to reverse the trend toward secularization and antipapal sentiment among the Roman *populus*.

The extension of the former cardinal's building along its northeastern flank was carried out at the same time as alterations were made to the old palace (Fig. 5). The former *piano nobile* became the mezzanine; the third floor became the *piano nobile*; and as a result of these operations the loggia of the small original tower was now located on the same level as the top story of the papal palace. The cardinal's palace was thus adapted to conform to new proportions developed for the papal palace. Work on the new palace began around 1466 with the large vestibule on the "*platea nova*." The vestibule joined the two parts of the complex and corresponds almost exactly to the middle of the present-day facade. The entrance hall covered a medieval road that had bordered the cardinal's palace and that is still present beneath the fifteenth-century floor. This medieval road diverged from the end of the Via Lata and offered access to the lateral door of the basilica of San Marco.

The vestibule, which served as the entrance to the residence quarters of the palace and which permitted access directly to the pope's private apartments, is distinctive. Its barrel vault is distinguished by deep coffers that literally duplicate the interior coffering of the Pantheon. Such knowing appropriation of the architectural patrimony of the classical past marks the true beginning of the distinctly Roman Renaissance. Moreover, the coffered armature vaults verify the crucial readoption of ancient construction tech-

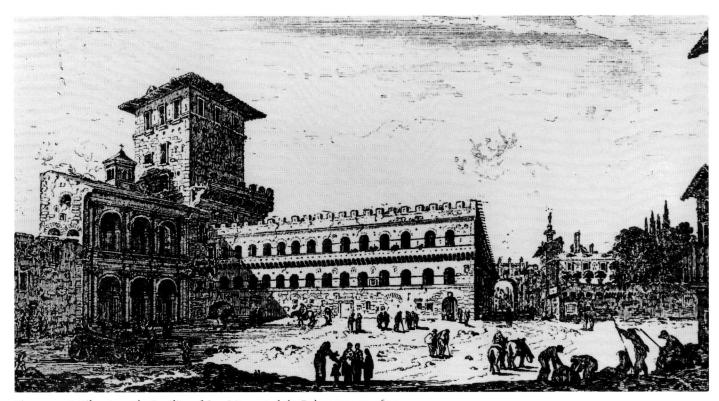

Figure 4 I. Silvestre, *The Basilica of San Marco and the Palazzetto*, ca. 1640.

10

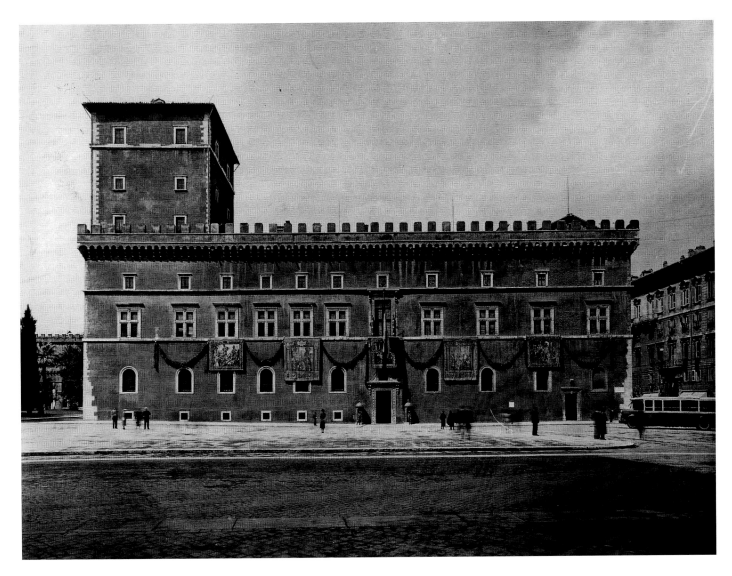

niques. The significance of this technical feat should be considered independently from the notion that Leon Battista Alberti intervened directly in the design of the vestibule.

Evidence for work on the *piano nobile* and on the installation of the cross-bar windows has been found in documents from the period between 1467 and 1469. Then, from 1469 and 1471 records indicate payments for the ceilings, the windows, and the upper corbels of the facade.

Construction of the large tower, which was articulated with crenellations until 1546, is mentioned for the first time in 1470. This structure was added in order to render the papal palace more secure. Joining the tower to the *viridarium* did away with the dangerous bridge between the edifices ordinarily used by Paul II. At the same time the tower served, literally and figuratively, as the cornerstone of the new complex by linking the buildings of the palace and the garden. Its massive, uniform front—a perfect antithesis to the controlled, meticulous appearance that characterizes Florentine civic architecture—is uninterrupted by any vertical articulation. There are no half-columns or pilasters to break up the solid weight of the wall. Instead, the horizontal division into three wide zones, marked by

Figure 5
The Palazzo Venezia in the 1930s.

two bands that indicate the floors within, emphasizes the longitudinal mass of the building. The stringcourses highlight, rather than hide, the asymmetry of the vast surface that was determined by the arrangement of the internal spaces built during two different phases of construction. This asymmetry is further stressed by the unequal distribution of the windows on the *piano nobile*, six where the earlier cardinal's palace had been, and four in the part to the right of the entrance. Behind these latter four windows are the great audience halls. The true novelty of this design is the preeminence afforded the *piano nobile* over all other elements on the facade, an arrangement that would become standard practice in Roman architecture. The *piano nobile* is characterized by the feature, unprecedented in Rome, of the cross-bar window. Although such windows were known in antiquity, their use in the Renaissance may have been equally inspired by the example of the papal castles of southern France. In Rome this type of window first appeared in the middle of the century. An inscription announces, in large beautiful letters in the ancient manner, the name of the builder-patron: PAULUS PP. II. With the exception of the house of Lorenzo Manili in the Ghetto, this is the first time that a pure *all'antica* script appears on a Roman building in the fifteenth century. Although the palace's crenellated top, inspired by the Vatican palace of Nicholas V, must have seemed archaic by contrast, it linked the building with the style typical of so many Roman structures built during the middle of the fifteenth century. The anonymous eclecticism of the entire palace, while lacking stylistic coherence, does underscore the Pope's desire to "do it up in a grand fashion," a sentiment perfectly in accord with the more "worldly" side of Paul II's personality.

Perhaps the most surprising detail on this already unusual facade is, however, the unexpectedly "flowery" entrance portal (Fig. 6). Although it is a virtual anthology of Albertian motifs, it possesses a "Venetian" quality in the joyous abundance of its decorative detail. Such sculptural embellishment, transferred from the interior to the exterior of the building, reflects Alberti's idea that "ornament" should have a vital role in the urban landscape.

The papal palace includes at least two revolutionary innovations that altered forever the history of Renaissance architecture: the use of the courtyard, which broke definitively with the medieval concept of the Roman house; and the careful arrangement of the rooms of the interior according to purpose. The functional division and organization of the space of the building in relation to practical needs can be traced to earlier plans for the Vatican apartments of Nicholas V. At Paul II's palace other modifications distinguish the arrangement of the interior from its predecessors. Between the public and private sections of the palace one finds practical divisions and, at the same time, effective connections. Moreover, the physical impact of the various rooms is defined by a discerning use of proportion and ornament.

The completion of structural work on the walls of the palace as far as the great staircase and on the door corresponding to the Via Papale (the modern Via del Plebiscito) fixed the form of the Pauline residence. During this phase of construction, the oldest wing of the palace, today known as the Barbo apartments, was united with the monumental Map Room, the Audience Hall, and the Royal Hall. The older rooms of the mezzanine, used perhaps as a summer residence, and the corresponding rooms behind the large tower on the *piano nobile* formed the most private part of the house, reserved for the "leisure" of Paul II. In contrast, the new grand halls were intended to form a suitable backdrop for official receptions.

With the death of the pope in July 1471, the task of concluding the most important work on the palace fell to his nephew and successor, Marco Barbo. The entry portal on the north side of the palace and the portico of superimposed orders that faces the large internal courtyard are two highly significant features from this period of construction. Datable to around 1470, the door facing the Via Papale delineates the outer edge of the Pauline building (Fig. 7). More important, it is the most elaborate example of Tuscan aesthetics applied to the otherwise mostly Roman body of the edifice. An enormous Florentine aedicula, recalling Donatello's niche on the exterior of Orsanmichele in Florence as well as the sculptor's sacrament tabernacle for St. Peter's, the portal is defined by the inclusion of two elements typical of classical architecture. First, the enframing columns, replacing the more traditional pilaster strips, are tributes to the legacy of the Pantheon. Second, the extremely tall plinths are derived from those that appear on the triumphal arches of Septimius Severus and of Constantine. The upward thrust of these elements of the portal emphasize a vertical movement and counterbalance the horizontal mass of the building's length.

The large internal portico, the counterpart to the corner between the modern Piazza Venezia and the Via del Plebiscito, is formed by four arcades with superimposed orders placed just behind the apse of San Marco and six

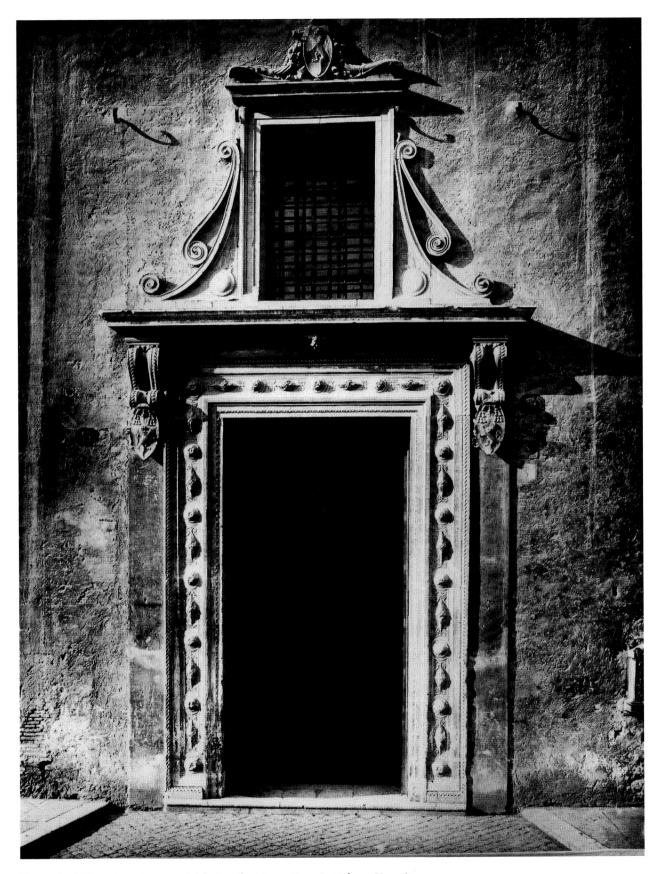

Figure 6 Fifteenth-century portal facing the Piazza Venezia, Palazzo Venezia.

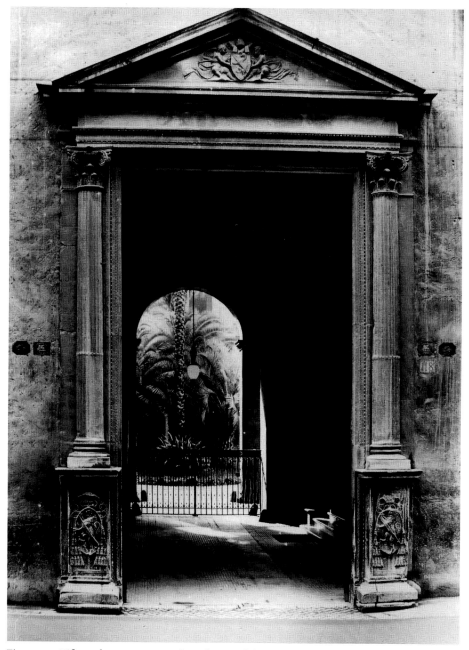

Figure 7　Fifteenth-century portal on the Via del Plebiscito, Palazzo Venezia.

that run parallel to the northern front of the palace (Figs. 8 and 9). The portico itself is incomplete, and there are neither indications of where or how it might have been extended throughout the courtyard; nor have any traces of foundations been found. The most likely explanation for this unfinished portico is that the palace originally must have been planned to encase a square courtyard, perhaps with five arches on each side. But it is worth remembering that the unifying motif of repeating porticos reappears almost obsessively both in the *viridarium* and in the loggia of the adjacent basilica.

The palace loggia, without a doubt, represents the single most significant element of the entire complex of San Marco. It is the first and, at the same time, the fullest articulation of the assimilation of classical forms and proportions into the formal language of Roman fifteenth-century architecture. The most important of the elements derived from the antique is the columnar order that is both projected onto the exterior surface of the arcade yet appears almost to be absorbed within it. Modeled on the arcades of the Tabularium, the theater of Marcellus, and the Colosseum, this same formal vocabulary was used not only on the loggia facade of San Marco and in the courtyard portico of the Palazzo Venezia, but also on the destroyed benediction loggia, begun by Paul II's predecessor Pius II, that once stood in front of the atrium at Old St. Peter's.

There is universal scholarly agreement that the severe grandeur of the portico, which is forcefully articulated in the rough bulk of Roman travertine, reflects the architectural theories of Leon Battista Alberti. Comparable evidence of the architect's thinking about the relationship between column and wall is

found in Alberti's major works, especially the Tempio Malatestiano in Rimini. Yet, the Roman palace has a strong upward momentum not found in other Albertian structures. Like the exterior portal, this verticality is achieved by the high bases supporting the half-columns on the ground level. The bases, which are not repeated on the pilasters behind them, correspond visually to the parapet of the upper order. This solution, along with the span of the trabeation above the capitals, and, with respect to classical models, the diminished projection of the half-columns, significantly lightens the visual effect of the arcade. In the end, the seemingly *all' antica* system results in a strikingly free interpretation of the classical canon.

The *fortuna critica* of the Palazzo Venezia

In Rome, the great building campaigns from the middle of the century (ca. 1450-1470) centered around the Vatican and San Marco. A study of the architectural genesis of the intricate Pauline complex reveals the paramount significance of the contributions made by the palace and its related structures to the development of Renaissance architecture. Lacking a single architect to whom all these innovations may be credited, the Palazzo Venezia has become for historians the most important example of collaboration or "teamwork," especially in terms of its actual construction, in the entire Roman fif-

teenth century. It is precisely this collaborative character that makes attempts to attribute the design to one architect even more difficult. Indeed, the validity of searching for such a figure is itself now the subject of heated debate. Clearly possessing exceptional skills as craftsmen, the individuals who took turns directing the work at the papal palace do not always appear to have maintained an equally high level of theoretical knowledge or artistic discernment. Although it is a monument of the greatest importance, architectural historians are further than ever from being able to attribute its design, which developed over the course of thirty years, to a single mind. The building of the Palazzo Venezia

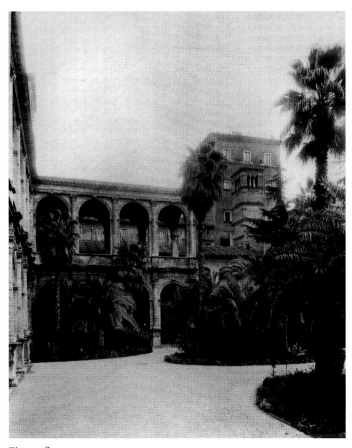

Figure 8
Eastern wing of the loggia, late fifteenth century, Palazzo Venezia.

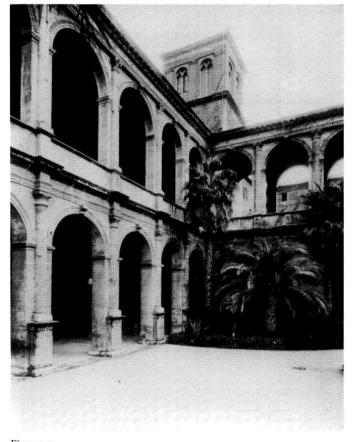

Figure 9
Western wing of the loggia, late fifteenth century, Palazzo Venezia.

involved too many artistic and structural alterations to be considered the product of a single personality.

Yet, the debate continues. The names most frequently put forward by historians, aside from Vasari's erroneous attribution to Giuliano da Maiano, are "Bernardo di Lorenzo, *carpentarius;*" Domenico di Francesco, master of woodworking; Giovanni dei Dolci, inlayer-joiner; and Jacopo di Pietrasanta, sculptor. These men might have been what we would term today the "architect," because the medieval convention still operative in the early Renaissance did not distinguish between the designer and the craftsmen who carried out the design. Instead, the term *architetto* designated a role somewhere between supervisor, director of works, and coordinator of the various teams of specialized laborers and craftsmen. In this context, the name of Francesco da Borgo Sansepolcro, called *"architectus ingeniosissimus"* by the two official biographers of Paul II, Gaspare da Verona and Michele Canense,

emerges as another possibility. Yet, in the face of total silence in the documents, not only regarding a supposed plan for the San Marco complex but also concerning Francesco's architectural activities in general, it appears more realistic to consider him (as, in effect, he was) a not atypical member of the Church hierarchy: a *"scriptor apostolicus,"* that is, a trusted administrator for the pope and the coordinator of the complex works that revolved around the Pauline buildings. Leon Battista Alberti's enigmatic and perhaps fleeting presence is evoked by the two most classical elements employed in the palace: the vaulted entrance hall that faces the Piazza Venezia and the double loggia of the courtyard. Yet, there is no contemporary evidence for his involvement in the construction of the palace. He should, therefore, probably be seen only as the source of the ideas, perhaps even the "prompter," for those specific features that most resemble his own work. This role, in turn, should be set within the larger picture of Alberti's position as

counselor for the pope's artistic strategy. The details differ too much among themselves and too much from Alberti's known buildings to be able to identify him as the author of a specific plan for the palace itself or, indeed, to attribute to him anything more than inspiration on a theoretical level.

Beyond the problems of individual contributions, which are far beyond the scope of this introduction, the substantial and profound "Roman-ness" of the San Marco undertaking constitutes the most immediate and lasting gift of Paul II to the urban renewal of Rome. Consistent with contemporary developments in painting and sculpture, the distinctive physiognomy of the Palazzo Venezia manifested the new spirit of Renaissance Rome, a spirit that was inspired by the city's glorious past while anticipating Rome's splendid future.

Maria Letizia Casanova
DIRECTOR
MUSEO NAZIONALE DEL PALAZZO DI VENEZIA

16

A Brief History of the
Museum at the Palazzo Venezia

The history of the Palazzo Venezia and its museum may be traced from its birth down to the developments of recent days. Over the course of its long life two protagonists stand out: the Venetian Pietro Barbo, cardinal and patron of the basilica of San Marco al Campidoglio, who was elected Pope Paul II in the summer of 1464 (Fig. 1); and Federico Hermanin, Superintendent of Museums for the province of Lazio and one of the principal scholars of the Roman Middle Ages. We owe to him the discovery in 1903 of the Cavallini frescoes in the Roman church of Santa Cecilia in Trastevere. And it was Hermanin who, in 1916, created the first museum at the Palazzo Venezia.

In 1455 Cardinal Pietro Barbo was responsible for enlarging the cardinal's small residence attached to the basilica of San Marco, as well as its conversion, ten years later, into the more appropriately grandiose papal quarters. The latter operation required transforming the entire area around San Marco, which until 1465 must have been a neighborhood of irregular buildings crowded along narrow and winding alleys.

Within this palace the cardinal kept his famous collection of precious objects, including ancient coins, jewels, silver vases, small bronze figures, tapestries, embroidered works, ivory diptychs, and engraved gems. On July 18, 1457, seven years before Barbo ascended to the papal throne, an inventory of his collection by the notary Giovanni Pierti (or Pierzi) listed approximately one thousand objects, most of which

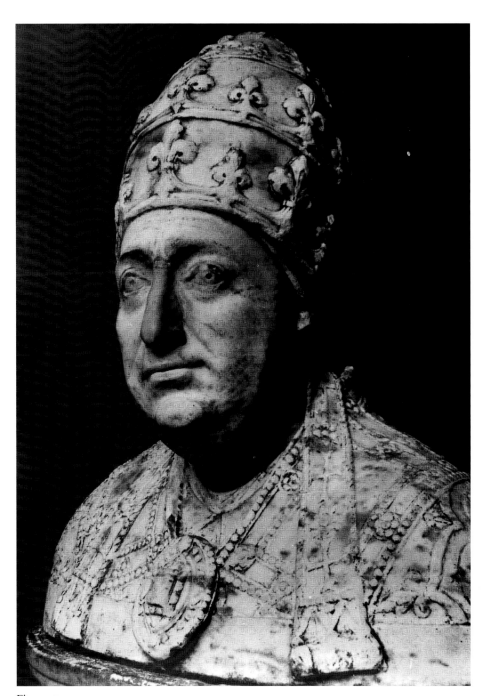

Figure 1
Fifteenth-century sculptor, Roman school
Portrait Bust of Pope Paul II, ca. 1470
Marble, ca. 59 cm.
Collection of Museo Nazionale del Palazzo di Venezia, Rome

were ancient imperial engraved gems and stones.[1]

One of Pietro Barbo's contemporaries, the Tuscan humanist Cardinal Jacopo Ammannati Piccolomini (1422-1479), who was named *secretarius domesticus* by Pius II Piccolomini (1458-1464) and retained by Paul II Barbo, provides us with direct testimony of the latter's passion for collecting. In a letter to Eliano Spinola, Cardinal Ammannati Piccolomini urges his friend to overcome his reluctance and to donate to the pope icons, gold and silver vases, coins, and any other ancient objects he could find, for in this way they would be preserved and appreciated by true art lovers.[2] This letter, and in particular its reference to Spinola's reluctance, is an early indication of the skepticism that Paul II faced in Roman humanist circles, where he was perceived as being averse to culture and men of letters.

The outside of the papal residence was equally adorned with antiquities. In 1466 Paul II had the basin that originally stood in front of San Giacomo al Colosseo installed at the Palazzo Venezia. In August 1467 he had a red porphyry sarcophagus that was believed to have been carved for Santa Costanza (now in the Museo Pio-Clementino of the Vatican Museums) set up in the Piazza San Marco.[3]

Without doubt the pope's plan was to showcase his palace as the center of the city and of Roman life. In fact, the assembly which elected the pope's nephew Marco Barbo to the cardinalate met in this very palace on September 18, 1467. The Palazzo Venezia was also used to lodge important guests of the pope, such as Emperor Frederick III, who stayed there during a visit in 1468, and Duke Borso d'Este in 1471. Moreover, we know from that perspicacious and invaluable source, Jacopo Ammannati,

that the ceremonies arranged by Paul II on these occasions were so long and complicated that visiting dignitaries, even the emperor himself, were deliberately made to feel diminished.[4] Religious and political motives were closely intertwined in the pope's agenda; he wished to present himself as both religious and secular sovereign. Thus, it is surely not by chance that when he had himself portrayed on papal seals he is shown enthroned, wearing the attributes of power, flanked by two cardinals and attended by others who kneel before him.[5]

Self-aggrandizement was even behind Paul II's particular interest in the papal tiara and its symbolism.[6] In this he succeeded. The tiara made for Paul II is the feature that identifies him in one of the famous tarot cards made by Mantegna between 1460 and 1470. This same distinctive tiara reappears in a less well-known representation of Paul II from a codex now in the State Archives of Bologna.[7]

The splendor that surrounded the pope was criticized by his contemporaries, including the historian Giovanni Antonio Campano (1429-1477), who accused him of employing *"supervacuum quemdam cultum"* and at the same time offered his services as the pope's biographer. Campano argued that his words, not vain rituals, would secure the pope a lasting place in posterity. Unlike history, Campano writes, *"Aedes et statuae et trophaea, triumphales arcus, numismata"* are not eternal. But Paul II chose to fashion his own legacy; his palace and his revision of papal ceremony were to serve as his memorials.

The resulting clash between papal political aims and the values of humanist culture is reflected in the dialogue *De dignitate cardinalatus*, a defense of the principle of church poverty, writ-

ten in 1468 by Jean Jouffroy, the Abbot of Saint Denis, and dedicated to Cardinal Bessarion. The gap between the pope and the Roman humanists is even more clearly demonstrated by the so-called conspiracy hatched by a group of young intellectuals protected by the Cardinals Bessarion and Ammannati.[8] Among this group appear the names of Pomponio Leto and Bartolomeo Sacchi, known as Platina. Paul II's affirmation of the role of the pope-sovereign and the contemporary secularization of the humanists led to a breakdown in the relationship between scholars and the papal court. This alliance had begun with Nicholas V, was continued under Pius II, and, after the interruption of Paul II, would resume with the creation of the Vatican Library under Sixtus IV (1471-1484).[9]

This notorious debate was emblematic of political and religious controversies during the second half of the fifteenth century. Equally famous were the Roman carnival celebrations sponsored by Paul II on a scale unprecedented even in Venice. The Pauline carnival was not simply an annual festival endorsed by the Church, but also a political tool used to extinguish the final flames of the communal, secular spirit of "republican" Rome. Although Müntz believed that these changes should be related to the development of taste, modern historians more correctly interpret them as evidence of a symbolic purpose.[10] By the middle of the fifteenth century, Rome was no longer the medieval holy city, goal of pilgrims from every corner of Europe; nor was it the capital of the Roman Empire, where latter-day emperors, including Charlemagne, were crowned. But it had not yet become the Renaissance city of Julius II, Bramante, and Michelangelo. Rome was a city in the process of trans-

formation, and it needed desperately to maintain a political and social balance. This was the goal of Paul II, and it was apparent in his dealings with the Curia, the humanists, and the *populus*.

Considered in this light, Paul II appears more interesting and less two-dimensional than previous scholarship has suggested. In the eyes of nineteenth-century historians, he was always seen as the pope of celebrations and carnivals, as the pope who disbanded the Roman Academy and thus alienated the humanists, and as the pope with an obsessive passion for cameos and gems. According to legend Paul took his precious stones with him to bed, where he greedily ran them through his fingers. These same objects, however, formed the basis of the most famous early Renaissance collection of antiquities. Upon his death, it is probable that Paul II's collection was transported to the Castel Sant'Angelo and presented to his successor Sixtus IV, who used some of the gems as collateral to obtain important loans from the powerful Medici family of Florence.[11]

For a short time after the death of its founder, the Barbo palace continued to

Figure 2
View of the interior of the Palazzo Venezia, installation ca. 1930.

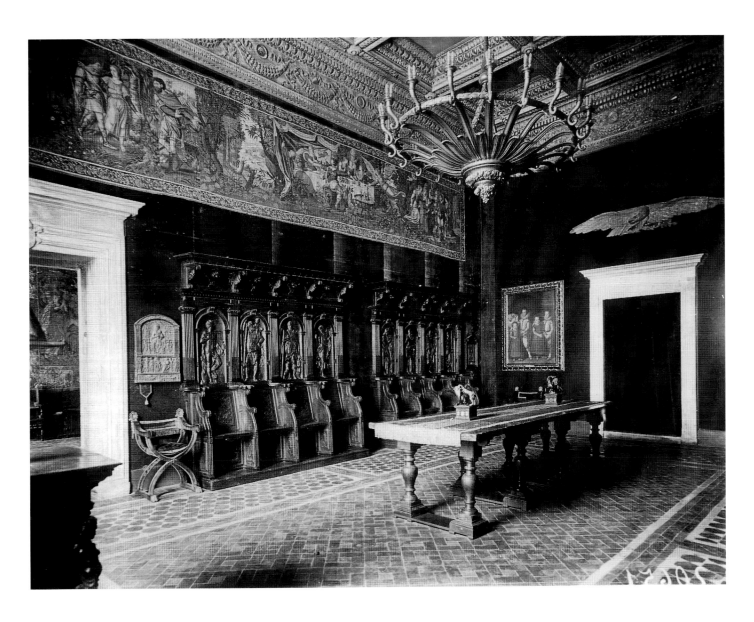

19

serve as a papal residence. Then, in 1564, it was ceded by the Church to the Venetian Republic for the use of its ambassadors. In 1797, following the Treaty of Capoformio, it passed to Austria. Finally, in 1916, the Palazzo Venezia was returned to the Italian government, which designated it as a museum and authorized the restorations begun under Federico Hermanin.[12]

Born in Bari to German parents, Hermanin (1868-1953) studied with Adolfo Venturi and was a university lecturer until 1899. Upon entering public service, he initially devoted himself to overseeing the completion of the Corsini Gallery. After this undertaking, he was put in charge of the Palazzo Venezia. There, the preservation of the Barbo apartments and the ceremonial rooms allowed him to recreate an environment evocative of the fifteenth and sixteenth centuries. To do so, he used paintings, sculptures, and furniture, some of which dated from the Renaissance and some of which were specially reproduced for his purpose. His intention was to create an ambience that would effectively reflect the history of the palace.

What Hermanin achieved is typical of late nineteenth-century taste (Fig. 2). He envisioned an installation that, "while possessing the grandeur of a museum, would also have a sense of freedom and life, a context in which the work of art could be more readily appreciated and admired." Displaying textiles, bronzes, furniture, and paintings from various periods, he cultivated an effect of opulence and eclecticism that is far from modern taste. An objective view of his efforts allows us to recognize that Hermanin was driven by a genuine, albeit emotional, response to the objects themselves and to craftsmanship of the highest quality.

In 1920 many of the works from the exhibition of medieval art, which opened in March 1911 at the Castel Sant'Angelo, found a home in the Palazzo Venezia. In 1922, however, Benito Mussolini, the Italian head of state, installed the government's political operations in the Palazzo Venezia, thereby making it the actual center of his new city. It was from its balcony that "oceanic" crowds gathered to hear his speeches and pronouncements.[13] During these years the museum suffered the inevitable consequence of being the seat of government; although officially open, it was accessible only by invitation (Fig. 3). Following the war, Hermanin was succeeded by a new director, Antonino Santangelo, who compiled catalogues of the painting and sculpture collections, the latter having doubled in size through gifts and purchases. More recently, successive reinstallations, carried out in 1984 and in 1988 under the direction of the architects Eugenia Cuore and Franco Minissi, have given the collections, as well as the galleries where they are displayed, new-found vitality (Fig. 4).

Figure 3
Entrance ticket to visit the museum in the Palazzo Venezia, ca. 1930.

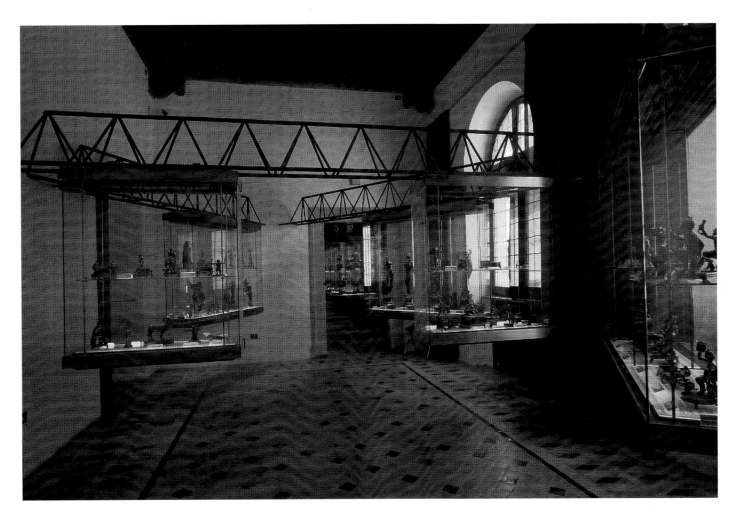

Figure 4
View of the interior of the Palazzo Venezia, installation of bronze statuettes ca. 1990.

The Formation of the Sculpture Collection

The Palazzo Venezia's sculpture collection consists of four sections: medieval and Renaissance marble sculpture; Italian and German wooden sculpture; Renaissance small bronzes; and clay models from the seventeenth and eighteenth centuries. How such important works came to the museum, no less than their respective provenances, is a complex story. In order to understand it, we must go back to 1911 and the exhibition held in Rome at the Castel Sant'Angelo as part of the *Esposizione Internazionale di Roma*. The undertaking was the result of collaborative efforts by Roman scholars such as Hermanin, Muñoz, Ashby, and Lanciani, along with the assistance of notable foreign scholars, including Pollak and Orbaan, as well as collectors. For this occasion, objects that were to serve as the core of a museum of medieval art were temporarily assembled at the Castel Sant'Angelo.

Works in marble, together with casts and reproductions documenting the uninterrupted activity of sculptors from the high Middle Ages through the fourteenth century, were exhibited along with works from as late as the seventeenth century. Among the many works put on view were the medieval marble sculptures that had been dismantled and removed from the convent and garden of Santa Maria in Aracoeli around 1884. These objects were stored in various places. Between 1909 and

21

1911 they were housed at the Castel Sant'Angelo; in 1916 some, though not all, were taken to the Palazzo Venezia.[14]

This core collection was expanded with the addition of fragments of medieval and Renaissance Roman sculpture from the area immediately surrounding the Palazzo Venezia. They came from the demolished houses and buildings on the slopes of the Capitoline hill, as well as from those structures dismantled in order to open the Via dei Fori Imperiali. Rapidly, the museum was able to boast a truly representative collection of sculpture in stone.

Between 1915 and 1920 a small number of wooden sculptures from the region of Lazio were added to the collection of the Palazzo Venezia. In 1933, the bequest of Enrichetta Wurts added to this meager nucleus, among other things, about 100 wooden sculptures in the round, most of them from *Flügelaltäre,* or altarpieces with side wings. These astonishing ecclesiastical creations, usually set up on high altars, were very popular in southern Germany between the fifteenth and sixteenth centuries. In addition to works by such famous figures as Veit Stoss and Michael Pacher, the Palazzo Venezia also conserves carvings by provincial Italian artisans from the Alto Adige and from Friuli.

In 1933 the museum acquired the small bronzes from the Barsanti collection, which was known through a catalogue written by Ludwig Pollak and Wilhelm Bode, published in 1922. The collection, consisting of 110 pieces, assembled an interesting core of Paduan and Venetian bronzes from the workshops of Riccio and Severo da Ravenna. Equally noteworthy in the Barsanti collection is a select group of small Florentine bronzes, all of which can be traced back to Giambologna and his students.

An extraordinary windfall came to the museum from the unlikely source of Evan Gorga, the tenor who had originated the role of Rodolfo in Puccini's *La Bohème.* A connoisseur of musical instruments (his collection of 3,000 pieces is preserved in the museum at Santa Croce in Gerusalemme in Rome), Gorga was not only an avid but also an omnivorous collector, acquiring all manner of things from archaic arms and armor to toys, bronzes, and terracottas. In all, Gorga amassed nearly 150,000 items. Encompassing thirty distinct collections, there were so many objects that Gorga had to rent ten apartments in downtown Rome just to store them. In 1920 Gorga offered to give most of his holdings to the Italian state, but the government instead seized them. Subsequently, this enormous collection had to be inventoried and catalogued, an operation which took years, as the sequestered objects had been moved to various makeshift storage areas. Only on November 27, 1949, was an actual agreement signed, but the government never honored its promise to build a conservatory for young singers in exchange for the collection.

The example of Gorga, who followed the dictates of his own intuition, illustrates how sophisticated one collector's taste can be. Undoubtedly, he acquired things in various ways. The recent discovery of records for an auction held in Rome at the beginning of the century speaks to the point, as they record what was sold and to whom. The sale included numerous *bozzetti* or clay models and plaster casts of Roman sculptures from the seventeenth century. The best pieces went to three people: Pollak, the leading figure in the Roman art market during the first decades of the century; Piancastelli, the former director of the Borghese Gallery;

and Evan Gorga. By various routes some of these works eventually entered the museum of the Palazzo Venezia.

In 1955 the Museo Artistico Industriale, which had been founded in 1872, had to be dismantled for lack of a new exhibition hall. Its collection was dispersed among various Roman museums, including the Palazzo Venezia, which received, among other things, the four marble reliefs by Mino da Fiesole (Cat. Nos. 1-4).

In 1952 Margaret Nicod Sussmann donated ten clay models of superior quality. These included Carcani's *bozzetto* for the tomb of Cardinal Favoriti in Santa Maria Maggiore; a *St. John the Baptist* by Caffà; a *St. Gregory the Great* by Mazzuoli; and a rare work by Giulio Cartari, a *Cupid and Psyche.* The museum also made acquisitions from the art market: Pierre Le Gros's *bozzetto* (1697) for a monument to Pope Innocent XI and a pair of splendidly framed, oval reliefs (1694) now attributed to Giuseppe Mazzuoli (Cat. Nos. 21 and 22). In 1963 Ambassador Giacinto Auriti donated his collection of small bronzes to the museum. Consisting of 113 pieces, it includes the *Bagpipe Player* and the *Peasant Leaning on a Staff* (once called the *Pilgrim*) by Giambologna (Cat. Nos. 8 and 9); a figure of *Faith* by Tiziano Aspetti (Cat. No. 6); and an *Écorché* or *Flayed Man* once attributed to Grupello (Cat. No. 20). With the Auriti collection also came a considerable number of objects of everyday use: boxes, vases, bells, and watches. Although such objects are not always of great artistic merit, they do have considerable historical value. In 1972 the museum added three splendid *bozzetti*, acquired in London, to its collection of terracotta models: a study (1682) by Michel Maille for a relief in the chapel of San Pietro d'Alcantara in the church of Santa Maria

in Aracoeli; the *Allegory of Faith* (1674) by Ercole Ferrata; and the model for Cosimo Fancelli's *Madonna of Savona* (1669). In recent decades the number of acquisitions has lessened, but the latest work to enter the collection is an ivory attributed to Jacob Cornelisz Cobaert (known as Cope Fiammingo) depicting the Virgin, the Dead Christ, and Nicodemus (1580-1590).

The Palazzo Venezia's rich collection of sculptures in marble, wood, bronze, and terracotta is further enhanced by a series of bronze plaquettes, both ancient and modern. The best were acquired by Domenico Ravajoli in 1958 and remind one of the famous collection of Cardinal Pietro Barbo mentioned at the beginning of this essay. This part of the collection also includes coins bearing the likeness of Paul II, which had been buried in the foundations of the Palazzo Venezia and were rediscovered in 1876.

Although this rich collection of sculpture is known to scholars on account of its important *bozzetti* and bronzes from the sixteenth through the eighteenth centuries, it is unfortunately unfamiliar to most visitors to Rome. Two fundamental, albeit dated, sources exist: a history of the palace written by Federico Hermanin (1948) and a sculpture catalogue edited by Antonino Santangelo (1954). In 1982 Pietro Cannata published a catalogue of the Renaissance and Baroque reliefs and plaquettes (*Rilievi e placchette dal XV al XVIII secolo*). In addition, between 1991 and 1993 Maria Giulia Barberini, Maria Letizia Casanova, and Pietro Cannata edited three catalogues devoted to specific aspects of the collection: *Scultura in terracotta dal barocco romano, Memoria della Fede*, and *Aggiornamenti e restauri*. In 1994 Carlo Gasparri and Maria Giulia Barberini published a study of the problematic group of terracottas attributed to Bartolomeo Cavaceppi, a Roman sculptor of the eighteenth century.

The German wooden sculptures, marble sculptures of the seventeenth and eighteenth centuries, and the ivory of Cope Fiammingo have been studied in various monographs, articles, and exhibition catalogues. Yet, the public is less aware of these collections, because, to date, they are not on view in the museum. Thus, the restoration of the marble reliefs by Mino da Fiesole, which was carried out on the occasion of this exhibition at the Georgia Museum of Art, represents an important step toward enhancing appreciation of the collection at the Palazzo Venezia and improving its installation. Upon their return to Rome, these four reliefs will be put on permanent view in the museum. Their cleaning is part of a larger undertaking planned for the future: a scientific catalogue of the medieval and Renaissance marble sculpture. In time these works of art will be exhibited to the public in the loggias of the "Palazzetto."

Given the diversity of the sculpture collection as a whole, the chief criterion in organizing this exhibition was to include artists who had lived and worked in Rome. Although limited by such practical considerations as the fragility or scale of certain works, the exhibition assembles marbles, terracotta models, and bronzes by artists such as Mino da Fiesole, Giambologna, Bernini and Algardi, and Mazzuoli—in short, a selection of the highest quality.

Maria Giulia Barberini
CURATOR, MUSEO NAZIONALE
DEL PALAZZO DI VENEZIA

Endnotes

[1] See Müntz, 1878, 181-287.

[2] *Epistolae et Commentarii*, 1506.

[3] Lanciani, 1902, 175.

[4] Cherubini, 1983, 175-256.

[5] Miglio, 1975, 121-53.

[6] Ibid.

[7] The codex records the *Costituzioni* or statutes of the Bolognese *Studio*; see Donati, 1958, 49 (fig. 12).

[8] *De dignitate cardinalatus* (BAV, Ottoboni lat. 793) is discussed by Miglio, 1975, 121-53.

[9] Brezzi, 1986, 1-18.

[10] For a discussion of this carnival see Rodocanachi, 1901, 164-92; for different interpretations see Müntz, 1897, 311 and Prodi, 1982, 101.

[11] Ulrico Pannuti, "Formazione, incremento e vicende dell'antica raccolta glittica medicea," in Dacos, et al., 1980, 3-15.

[12] See Casanova, 1992, passim, for the history of the building and its restoration as a museum.

[13] It is, in one of fate's ironic twists, also the balcony from which Mussolini's hanged body was displayed to the people.

[14] Di Gioia, 1988, 285-334.

Note: *For full citations here, and elsewhere in this catalogue, see the Bibliography. Works not appearing in the Bibliography are given complete citations in the Endnotes.*

"With Superior Thought"
Renaissance and Baroque Sculpture from the Palazzo Venezia

SCULPTURE PLAYS LITTLE ROLE IN the visual landscape of urban America at the end of the twentieth century.[1] Only an occasional memorial (some half-forgotten hero, martyr or founder) may rise up among the trees in a park or designate the intersection of two streets.[2] Our fountains tend to be metallic, chilled contraptions; our bridges technological feats of pure engineering. Our histories are reduced to inscribed plaques posted along roads for passengers in moving cars to read, and our tombs are timid, monotonously unobtrusive stones hugging the ground. In contrast, Italy between the fifteenth and seventeenth centuries was a different world. A visitor would have seen countless sculptures decorating churches, fountains, and bridges, not to mention the facades of public and private buildings. In numerous churches, religious sculptures stood in niches, over entrances, and on exterior buttresses, while carved tombs and altars filled the interiors. Monuments to heroes, saints, martyrs, and contemporary rulers stood in public piazzas, beside churches, and in private courtyards. Obelisks and commemorative columns marked major thoroughfares and offered visible proof of the historic link between past and present. Especially in Rome, antique sculptures rubbed shoulders with modern works, and everywhere such sculptures exhorted the public to virtuous acts and to the remembrance of their noble lineage. Far from being a quiet, dusty emblem of things past, sculpture was a vibrant means of celebration and communication. The contemporary loss of

sculpture as a vehicle for the expression of personal or communal identity and values makes it difficult for us to appreciate the vital cultural and social role that sculpture played in Renaissance and Baroque Italy.

The twenty-two works of sculpture from the rich collections preserved in the Museo del Palazzo di Venezia in Rome span the period from the second half of the fifteenth through the end of the seventeenth century.[3] With the exception of two works, one attributed here for the first time to Hendrick de Keyser (Cat. No. 12), all of the sculptures were produced in the geographic entity known as Italy. As a political concept, "Italy" was little more than a poetic fancy. Rome, Florence, and Venice were not cities united in one country; rather, they were independent governmental, social, and artistic centers, each owing their allegiance to different cultural and political traditions. Complicating this picture even further, each century saw different configurations of power and, therefore, different political demands upon art. Thus, while the pope ruled in Rome as both secular and spiritual leader, the nature of his power, both within the city and across Europe, altered considerably over the centuries. Fifteenth-century Florence was a city-state ruled by a republican government, but by the sixteenth century the Medici family had gained control of the city and the entire area of central Italy known as Tuscany. Yet another governmental form was developed in Venice, an oligarchy with a ruling doge (Venetian for *dux* or duke). Casting suspicious

eyes on each other, all three attempted to maintain their independence by political and military maneuvers.

What then, one might ask, is meant when speaking of Italian art or even Italian sculpture? The diversity explicit in the political and social realities of Italian cities was offset by a series of shared cultural expectations. Language was no small factor; even though each region had its own dialect, Latin was the *lingua franca* of government and law. More important was religion. Notwithstanding the upheavals of Protestantism in northern Europe during the sixteenth century, Italians remained resolutely Catholic. Individually and collectively, they saw themselves as the heirs of the great traditions of the Roman empire. This had a fundamental impact on the development of Italian art, especially sculpture.[4] Inspired by ancient examples, the monumental free-standing nude statue once again entered the Western tradition. Portrait busts, equestrian images of generals, bronze and marble statues of pagan gods were direct translations of ancient types. But even depictions of Old Testament prophets, the apostles, and Christ himself—one may cite Michelangelo's controversial depiction of a *Risen Christ* in heroic nudity (Santa Maria sopra Minerva, Rome)—were irrevocably altered by sculptors' assimilation of the works of their classical predecessors. The label Renaissance specifically refers to the "rebirth" of the classical past in a modern context, and nowhere is this more obvious than in the style and content of sculpture. Indeed, every piece in this exhibition

from the Palazzo Venezia, whether because of its medium, style or purpose, can be linked to an ancient type or concept.

As artists became increasingly knowledgeable about ancient art, the notion of art as a craft gave way to an awareness that artistic endeavor, like the study of the traditional liberal arts, was an intellectual activity. This, in turn, saw the emergence of artists who were as erudite as their patrons, which inevitably led to major changes in the social prominence of artists. By the fifteenth century, celebrated artists traveled frequently, working at the courts of some of the most powerful rulers in Europe. For instance, Mino da Fiesole, born in a small town east of Florence, worked for the Medici in Florence, the popes in Rome, and Alfonso I of Aragon in Naples; he also worked in smaller towns such as Volterra, Siena, Perugia, and Fiesole. He collaborated with equally peripatetic artists from Milan, Pisa, Naples, and even Dalmatia. Michelangelo, who always considered himself a Florentine, frequently moved back and forth between Rome and Florence. His first trip to Rome was in 1496; his final sojourn in Rome began in 1534, but after his death in 1564, his body was spirited out of the city to be buried in Florence. Born in 1598, thirty-four years after Michelangelo's death, Bernini spent his first years in Naples, his mother's birthplace and where his father, a Florentine, had found work, but it was in Rome that the precocious youth became world-famous. He traveled, briefly and unhappily to Paris, where in 1665 Louis XIV rejected his design for a facade. In Rome, however, he not only enjoyed high status but also achieved enormous success. Because of his service to the papacy, Bernini was knighted in 1621 by Pope Gregory XV.

Between Michelangelo and Bernini, two giants who each dominated his respective century, other sculptors played significant roles on the European stage. Giambologna, an artist born and trained in Douai, came to Rome in the 1550s and remained in Italy for the rest of his life, working for the Medici court in Florence. His followers, Susini among them, sent sculptures to patrons throughout Europe. Artists had become men of renown, their works widely disseminated, and their ideas debated. One need only consider Vasari's *Lives of the Artists* to understand that by the middle of the sixteenth century, the social position, if not the functional role, of the artist had risen. Francisco de Hollanda's *Dialogues*, Aretino's letters, Condivi's biography of Michelangelo, and the latter's poetry all demonstrate the cultural impact to which artists, following the example of Michelangelo, could aspire.[5]

A discussion of the formal principles of Renaissance and Baroque sculpture reveals both the continuity and the transformations that occurred across three centuries. By means of the sculpture in this exhibition, one may follow the broad stylistic development of Italian sculpture. The four marble reliefs by Mino da Fiesole from the first years of the 1460s (Cat. Nos. 1-4) build on the critical contributions made earlier in the century by Ghiberti and Donatello. The emphatic perspective, the narrative complexity, the stock gestures and costumes, the combination of generalized forms and precise details all evoke aspects of early Renaissance sculpture. Tribolo leads us to the age of Michelangelo. The former's terracotta reduction (Cat. No. 5) of Michelangelo's marble figure of *Night* from the tomb of Giuliano de' Medici at San Lorenzo in Florence (Fig. 1) stands for the entire

High Renaissance period and the early *Maniera* that followed it, suggesting the breadth and scope of Michelangelo's influence in the sixteenth century.[6] Comparing the two, the marble and the variant produced by Tribolo, one recognizes how Michelanglo's art was at once inescapable and beyond the reach of other sculptors in his wake. The eccentric proportions and scale of Michelangelo's figure—that quality of being not so much a depiction of the universal female form, but being something more, something different, a vision that bears only a passing resemblence to "real life" and that was created, as God created Adam and Eve, from the mind of Michelangelo—have been returned to nature by Tribolo. The awesome weight of the raised thigh, the seemingly endless length of torso with breasts that are somehow more decorative than nurturing, the frightening presence of the owl and mask all are deleted. Michelangelo's *Night* is stripped of her terrifying aspect and is transformed into an ideal, sensuous woman. She rests on a rocky base almost like a fountain figure; her complex, twisting pose, so alarmingly tense in the marble, now has a stylized elegance, an almost choreographed quality. To follow Michelangelo was impossible; one could only go around him.

Sculptural style in the second half of the sixteeth century is uncomfortably labeled mannerist, following the designation originally assigned to painting. But, in sculpture as in painting, there is enormous diversity, depending on function, regional expectations, and traditions. In this exhibition, the works representative of this period are all bronze statuettes. The independent bronze statuette first appeared in the fifteenth century as a conscious revival of an antique type. Sophisticated col-

lectors owned bronze copies of famous antique sculptures as well as other bronzes that depicted classical subjects.[7] In these relatively small bronzes, the precision of the worksmanship and the details of expression and action were meant to be admired at close range. By the sixteenth century, the production of small-scale bronzes represented an important part of the activity of large sculpture workshops in Florence and Venice. The figure of *Faith* by Tiziano Aspetti (Cat. No. 6) relates to a series of large-scale bronze *Virtues* in the basilica of Sant'Antonio in Padua.[8] It is also one of numerous similar figures produced in his workshop as decorative finials for andirons. Different attributes were added to what was essentially the same model in order to produce the iconographic pair desired by the patron. The spiral twist of the pose, referred to in the Renaissance as a *figura serpentinata* (serpentine figure) depends on a series of elegant constrasts: the verticality of the weight-bearing leg parallels the extended position of the figure's right arm; the slight projection of the right leg is matched by the raised left arm, bent at the elbow to bring the hand delicately across the chest. The counterbalance of limbs is enlivened by the exaggerated sway of the hips, the dip of the shoulders, and the turn of the head. This is not a true *contrapposto* pose, with its careful balance of contrasting limbs, because no suggestion of forward movement is intended. Rather, the figure creates a helix, pulling the eye endlessly in a circle that coils up the body and then, directed by the downward gaze, returns to the base to begin again. The elaborate coiffure, the pseudo-classical garments pulled back to reveal the legs, and the highly polished surface underscore the exquisitely refined nature of

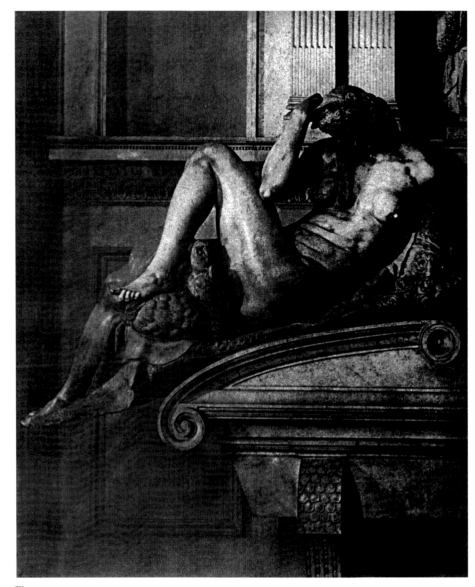

Figure 1
Michelangelo, *Night,* 1526-1531.
Marble, width of block 1.94 m.
Tomb of Giuliano de' Medici,
New Sacristy, San Lorenzo, Florence.

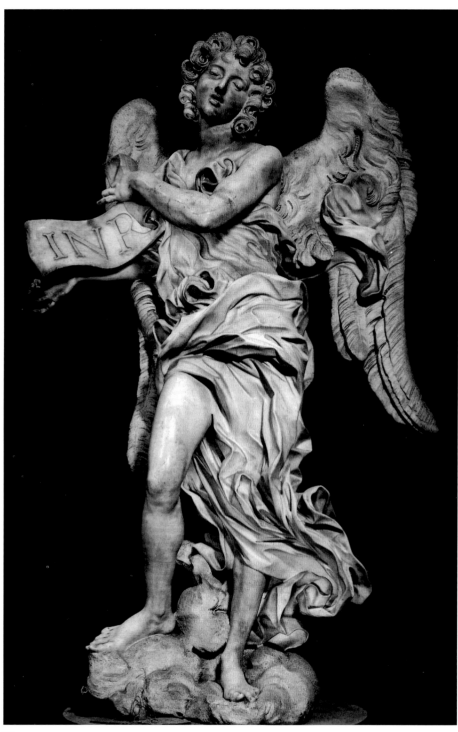

Figure 2

Gianlorenzo Bernini, *Angel with the Superscription*, 1668-1669.
Marble, over life-size (ca. 3.25 m).
Sant'Andrea delle Fratte, Rome.

the figure rather than any religious sentiment. The sophisticated pose and aloofness of feeling, paralleling its meaning as an abstract personification, convey the sense that it is an object to be admired for its beauty. In this and other works from the period aestheticism was its own cult.

The changes wrought during the Baroque period are perfectly expressed in a comparison between Aspetti's *Faith* and Gianlorenzo Bernini's terracotta *bozzetto*, or study (Cat. No. 15), for a monumental marble angel intended for the Ponte Sant'Angelo (Fig. 2), the bridge leading from the center of Rome to St. Peter's.[9] The self-contained and self-sustaining spiral of the former has been opened up and expanded outward in the latter. The two works are not without parallels: the elaborate curls of hair, the complex drapery, the exaggerated thrust of the hip, even the downward glance to the left. But in Bernini's hands the pose, rather than mere refinement of form, conveys an intensely felt and dramatically realized energy. Each detail has been broadened (the legs are wider apart, the head is more firmly turned down and to the side) and expanded to suggest not an idealized, immutable stance but a purposeful action in space. Underscoring this sense of an event unfolding, just as the scroll is being unfolded by the angel, are the billowing folds of the drapery. They no longer hug the body, outlining and defining its position, but they respond to the force seemingly generated by the figure's own movement and by the reaction of the atmosphere surrounding it. This small study in terracotta for a monumental, over life-size sculpture to decorate the bridge seems to be landing on its base, bringing down from above its emblem of Christ's pas-

sion, the superscription nailed on the cross above His head. Crossing the bridge over the Tiber, on one's way to St. Peter's, the marble angel and his companions surround you, miraculous apparitions of divine truth (Fig. 3). Here Faith is no longer an abstract state, as conceived by Aspetti, but has become, through Bernini's art, a vibrant persona in the celestial drama being re-enacted in stone.

The paired reliefs of the *Virgin Annunciate* and *Angel of the Annunciation* (Cat. Nos. 21 and 22) are by the Sienese sculptor Giovanni Mazzuoli.[10] A pupil of Melchiore Caffà and Ercole Ferrata in Rome, Mazzuoli also worked for Bernini, carving the figure of *Charity* for the tomb of Pope Alexander VII.[11] Still in their original carved wooden frames, the reliefs again rest on that ambiguous line between devotional art and works produced primarily for their aesthetic value. The pure white marble is manipulated to create pockets of caressing shadow and light-absorbing form. The careful articulation and polish of the various textures of hair, flesh, and cloth are distinguished from the matte striations of the background plane. The close-up depictions of the Virgin and the angel have the focused intensity of portraits, drawing our attention to the eternal, ideal beauty of these two single heads. The turbaned Virgin bends her head in quiet acceptance of her mission, while the angel, with a classical, Apollonian profile, parts his lips in speech. No longer activated by the dramatic energy associated with Bernini and his Roman school, Mazzuoli here anticipates the neoclassical style of the next century.

Such restraint is true even in his rendering of the theme of the Annunciation. Traditionally depicted as a narrative, the event is here reduced to two isolated profiles. There is no perspective space, and no mundane details reveal the Virgin's pious life before this event. Instead of the anecdotal, Mazzuoli emphasizes emotional and psychological effects. The rest of the story is supplied by the viewer.

The contrast between Mazzuoli's reliefs from the end of the seventeenth century and the four narratives by Mino da Fiesole from the middle of the fifteenth could not be clearer. Whereas Mino da Fiesole employed his chisel in a virtually endless search, comparable to the painted narratives of his day, for the precise details that might accurately define and explain the events depicted, Mazzuoli deletes all extraneous information. More significant than the change in narrative expectations is the alteration of the relief format itself. Mino's reliefs exist behind the invisible plane defined by the external edge of his reliefs. The narrative, therefore, takes place wholly within a fictive world created within the block of marble. Mazzuoli's figures project forward beyond the plane defined by the wood frames and the simple relief backgrounds. They have the plasticity and volume of life because they exist not in a fictive realm but in the viewer's space.

A discussion of Renaissance and Baroque sculpture entails more than a simple recognition that what is valued in one work is not shared by another. Style is but one means towards understanding. The purpose for which a sculpture was created is equally significant, since function compels both the form and content. Mino da Fiesole's altar of St. Jerome and Michelangelo's Medici tombs exemplify two of the major, monumental products of Renaissance and Baroque sculpture: ecclesiastical furnishings and sepul-

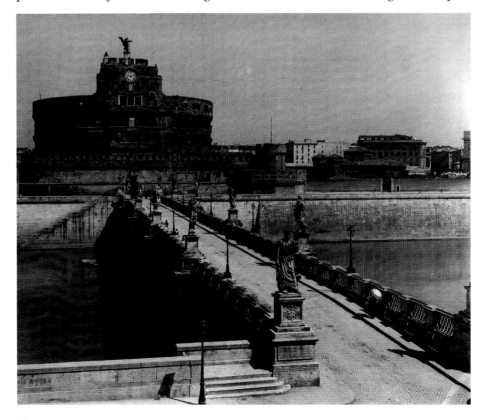

Figure 3
Ponte Sant'Angelo, Rome.

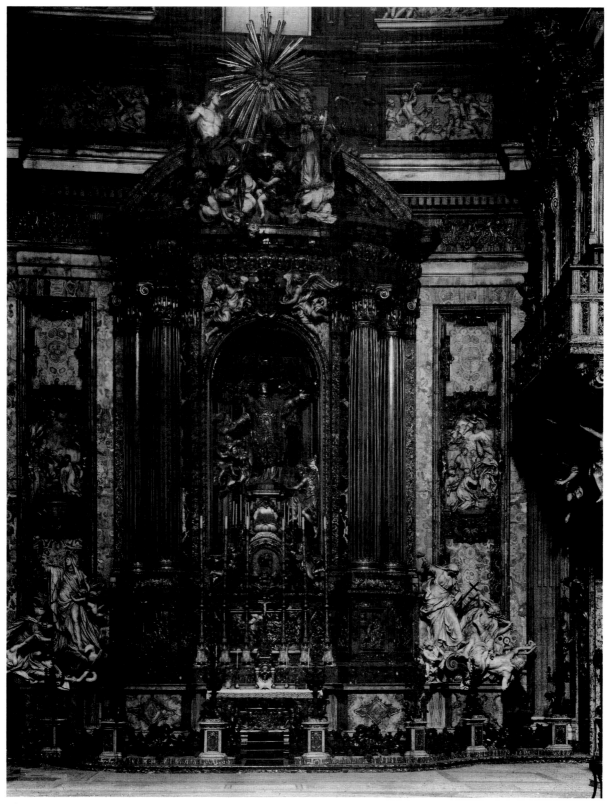

Figure 4
Andrea Pozzo, Chapel of St. Ignatius, 1697-1700.
Marbles, silver, gold and bronze.
Church of the Gesù, Rome.

chers. Quite different is Susini's bronze *Crucifix* (Cat. No. 11), discussed below is representative of the late *Maniera*, but it functioned principally as part of a religious rite.[12] Every consecrated altar at which the Mass was celebrated was required to display the Crucifix. Thus, the bronze by Susini, removed from its original context, once had a specific role to play in the Catholic ritual, one that perforce constrained the artist to invent within fixed iconographical boundaries. He could not, for example, suddenly decide to depict Christ as an elderly, rotund, or fully-clothed man. Our recognition of the ridiculous nature of these alternatives reveals how function and, in this case, iconography determine the image. Indeed, the genius of Renaissance and Baroque sculptors was their ability to work within an admittedly confined range and yet still place a personal stamp on the result. How different appears Susini's *Crucifix* from that before which St. Jerome kneels in the marble relief by Mino da Fiesole. Interestingly, both artists have chosen the less common "Y"-shaped position; more typically Christ is shown with his arms parallel to the horizontal bar of the cross. But Mino's Christ looks downward, heightening the connection between the Crucifix and the penitent saint, whereas Susini's Christ gazes toward heaven, directing our attention to the salvation offered by his sacrifice. This same contrast is emphasized by the position of the legs; in Mino's relief the splayed legs emphasize the weight of the suffering body, whereas the tightly locked legs of the bronze Christ push the body upward, minimizing the physical reality of the body hanging from the cross. These formal and symbolic differences should not, however, blind us to their shared purpose: both

are depictions of the defining miracle of the Christian faith and both, therefore, had to be immediately recognizable as such.

Susini's *Crucifix* belongs to a long tradition of both large and small-scale sculptural depictions of Christ on the cross. Such images have long been treated as part of the standard canon of Renaissance sculpture. But objects in precious materials, perhaps because of their strong associations with medieval practices and production, were once relegated to the category of "minor arts" and are only now beginning to be studied with the attention long dedicated to larger sculptures.[13] Alessandro Algardi modeled the gilded terracotta relief depicting the *Society of Jesus* (Cat. No. 13) as a study for the bronze relief that decorates the front face of the urn for the remains of St. Ignatius of Loyola.[14] This gilded reliquary is the centerpiece of the altar dedicated to the saint in the left transept of the chief church of the Jesuit Order, the Gesù, in Rome (Fig. 4).[15] With the addition of gold, the value of the model, made of simple baked clay, approaches that of the urn itself. Reliquary urns, like eucharistic tabernacles, employed precious metals in order to exalt the sanctity of the object being preserved. The urn for St. Ignatius, set within a bronze *paliotto* with kneeling angels, was sufficiently splendid to house the remains of the saint; it was retained even when the monumental altar that surrounds it was rebuilt. The form of many medieval and Renaissance reliquaries echoes the specific body part preserved, but St. Ignatius' served as his funerary urn. Oddly enough, given this sepulchral function, the relief does not concentrate on St. Ignatius alone, but depicts him among the other important early saints, blessed, and martyrs of the Society of

Jesus. The glorification of the entire company publicly commemorates the earthly mission of the Jesuits.

Reflecting secular rather than religious taste are the three genre figures in bronze by Giambologna and Romolo del Tadda. The incongruity of the humble subject and sophisticated style of Giambologna's extraordinary *Peasant Leaning on a Staff* (Cat. No. 8) is especially striking.[16] The pose, derived ultimately from an antique model, is a variation of that employed by the sculptor for one of his most elegant and refined figures, the statuette of *Apollo* for Francesco I de' Medici's *studiolo* in the Palazzo Vecchio, Florence (Fig. 5).[17] The nude Apollo is an idealized representation of an Olympian deity, the god of music and the arts, whereas the peasant is a contemporary figure, drawn from the lowest stratum of society. Such genre subjects were popular in Giambologna's native Flanders, and for this reason both the peasant and *Bagpipe Player* (Cat. No. 9) have been related to the northern European tradition of depicting realistic scenes and figures taken from daily life.[18] A similar taste for the humble, the clumsy, even the bizarre, was also found in ancient Rome. One favored place for the display of such figures was the private garden. This practice was consciously imitated by Italian patrons in the sixteenth century. Two famous Medici gardens, the Boboli and Pratolino, included large, stone, genre figures and fountains *all'antica*.[19] Both of Giambologna's statuettes probably reflect ideas first developed in the decoration of the gardens at Pratolino. Their small-scale replication in bronze allowed the compositions another life as decorative figures since Giambologna's statuettes exist in more than one version.[20]

The degree to which classical imagery and themes were embedded in

the visual vocabulary of sculptors can be judged by Ercole Ferrata's *bozzetto* for a *Triton*. (Cat. No. 18) [21] The son of Neptune, ancient god of the sea, and the nereid Amphitrite, Triton was a merman, half man and half fish. The name, however, refers generically to male sea creatures in the entourage of Neptune, Amphitrite, Venus, or Galatea. Famous examples are the creatures, one blowing on a conch shell, that surround the triumphant Galatea in Raphael's fresco in the Villa Farnesina.[22] In seventeenth-century Rome, that most Catholic of cities, both Bernini and Ferrata employed similar mythological figures for fountain decorations. The Palazzo Venezia *bozzetto* has been damaged: the *Triton* figure has lost the conch shell that he once held to his lips. In the original concept, water would spray from this shell into a basin below. The subject is perfectly wedded to its function. An ancient fantasy about the creatures who inhabit the seas was revived in Rome as a secular, decorative, fountain motif. This metamorphosis, begun in the sixteenth century, reached its apex in Bernini's famous sculpture *Triton* for the fountain in the piazza near the Barberini palace.[23] Ferrata's figure represents not only this integration of classical themes and Baroque style, but also the all-pervasive influence that Bernini wielded among seventeenth-century sculptors.[24]

The relevance of function is especially important when the iconography is less fixed. The primary purpose of the *Écorché* (Cat. No. 20) derives from its history. The tradition of the *écorché*, or flayed figure, can be traced to studies made by painters and sculptors of the human body, its muscles and bones revealing its capacity for movement. For, as Leonardo said, "that painter who has knowledge of tendons, muscles and sinews will know very well in the movement of a limb how many and what tendons cause it."[25] The transition from drawings to sculptures occurred in the sixteenth-century workshop where apprentices studied statuettes and *écorché* figures as well as live models. Significant for both artists and scientists, *écorché* figures were, like the comparable engraved depictions in manuals, widely distributed throughout Europe.[26] Yet, even here, where form seems dependent on purpose, it is worth recalling two previous traditions that involve the flaying, or skinning, of a male figure. Roman sculptures of the flayed Marsyas, the rival of Apollo, who was punished for his temerity, were much admired for both their inherent drama and their anatomical precision.[27] The apostle St. Bartholomew, who was martyred by being flayed alive and whose attribute is his own skin, appears directly beneath Christ in Michelangelo's *Last Judgment* in the Sistine Chapel. His tortured second skin includes facial features notably different from those of the saint himself; this second skin is often identified as a self-portrait of the artist.[28] The *Écorché* is clearly not simply an anatomical study; the very idea of the depiction or revelation of the "inner man" suggests a far more complex meaning. The bronze, once attributed to Gabriel Grupello, has a calculated refinement and elegance that is artistic, not merely scientific.[29] The prancing pose, pulled by unseen strings, implies the motion afforded living creatures. It might even be interpreted as an allegory of sculpture itself; with an *écorché* the artist illustrates the universal truth of man with only his bones and muscles, in bronze and marble, the sculptor creates a simulacrum of the entire living being.[30]

One also needs to consider the portrait, one of the major sculptural genres of both the ancient world and of Renaissance and Baroque Italy. Sculpted portraits can be divided into two major types: the bust and the profile relief.[31] Both types derive from classical examples. The supreme master of the portrait bust in marble, a genre revitalized by Mino da Fiesole in 1453 with the portrait bust of Piero de' Medici, was Bernini.[32] The profile relief, most typically but not exclusively in bronze, was, like the bust, associated with imperial Roman imagery. Beginning with Pisanello in the early quattrocento, bronze profile portraits of rulers *all'antica* were placed on coins and circulated as medals. On the other hand, the portrait was antithetical to Michelangelo's vision of artistic *ingegno* because, by their very nature, portraits require the artist to abandon his own style in favor of copying the appearance of external things: in other words, concentrating on the recognizable features of the subject.[33] The portrait in this exhibition, a profile medallion of *Pope Clement X* (Cat. No. 16) retains formal associations with the previous ancient and early Renaissance traditions. But in Bernini's hands, the flat profile has been transformed into an illusionistic rendering of a three-dimensional bust. The angled position of the upper torso and the contrast between the richly worked details of the *camauro* and *mozzetta* and the simplicity of the background, draw one's attention to the face, with its momentary expression, a true speaking likeness. The deeply modeled plasticity of the flesh, the carefully articulated texture of the hair and beard, even the projection of the ear, all suggest the real presence of a particular individual.

Of exceptional quality, this portrait medallion, which lacks a reverse, must

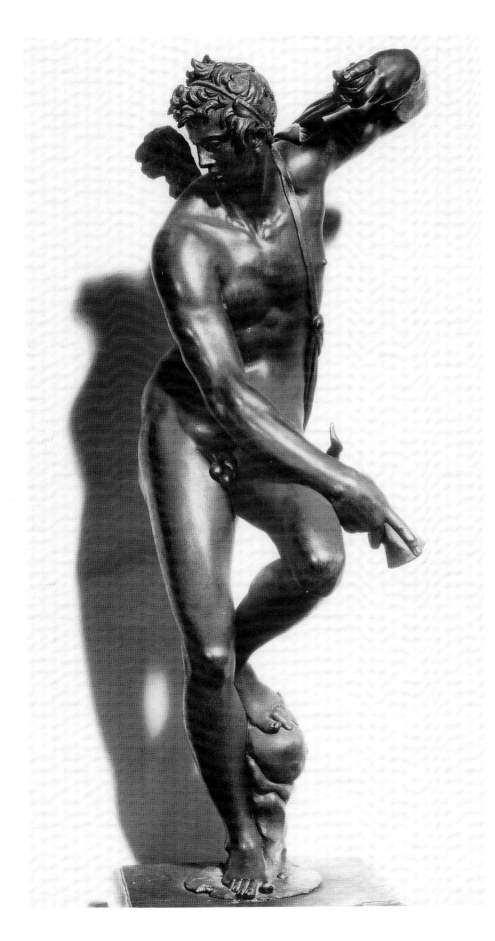

have been intended from the start for the pope himself. It probably also served as a model for other images that required the pope's profile.[34] In preparation for the bronze relief, Bernini seems first to have made a drawing: the red chalk drawing in Leipzig probably served both in the design of the medallion and as a study for the later marble portrait bust of the pope.[35] The profile drawing would have been made with the sitter before the artist; the medallion could then have been modeled in wax and cast in bronze in the workshop. From these preliminary works, variants could be made for coins and medals.[36] This complicated process of design, modeling, and replication is typical of the sorts of workshop undertakings assigned to Baroque sculptors.

Finally, it is this last topic, the creation of a work of sculpture, that demands attention. It is not enough to admire, appreciate, or even understand the formal and functional significance of a sculpture; one must also consider its genesis, literally the process of creation itself.[37] Turning again to Bernini's *Angel with the Superscription*, one can almost see traces of the molding fingers, the rapid building up of clay, the cutting and shaping of the object in space. This figure is one of a series of studies carried out by Bernini as he planned the monumental angels for the Ponte Sant'Angelo.[38] He made both drawings and *bozzetti* as he developed his ideas for these angels. Since most of the statues installed on the bridge were actually carved by his assistants, Bernini's models are often judged to be the most authentic records of his activity.[39]

Figure 5
Giambologna, *Apollo*, 1573-1536.
Bronze with red laquer, 88.5 cm.
Studiolo of Francesco I, Palazzo Vecchio, Florence.

These terracottas, literally "cooked earth," or clay fired in a kiln, preserve with remarkable immediacy the creative process of the artist.

Today we tend to think of this process in romantic terms: the isolated genius slaving away in his studio, creating a work of art that expresses his innermost feelings and ideas. This fiction has little to do with the practical realities involved in the production of sculpture in the Renaissance and Baroque periods. Many artists were masters of large workshops; they took on projects that entailed years of work and the help of many assistants. An aspect of the true genius of a successful artist was his ability to mediate between his own ideas and those of his patrons and between his creative aspirations and their interpretation by members of his shop. Even Michelangelo, notorious for being unwilling to tolerate assistants, actually employed an army of carvers for the Medici Chapel.[40]

A sculptor produced models to guide the members of his workshop as they labored on the final translation of his idea into stone or bronze. Models were also used, like drawings, as a means of considering, developing, and refining the master's intentions. By the time of Bernini, this dual process was clearly defined.[41] Beginning with drawings and small-scale *bozzetti* in wax or terracotta, the artist ideated the composition. When satisfied with the outcome, the rough, small-scale *bozzetto* could then be reproduced, concentrating on the details, or recreated full-scale, allowing the artist to judge the effect of his work on site. This final *modello* was then translated into stone. This process, fully worked out in Bernini's shop, was commonly employed by his contemparies, including Algardi (Cat. No. 13), Ferrata (Cat. No.

18), Caffà (Cat. No. 17), and Naldini (Cat. No. 19).

The traditions that led up to this highly effective system, however, are less consistent. Giambologna, also the master of a large and diverse shop, made *bozzetti* in wax and then *modelli* in terracotta and plaster, but he seems never to have used drawings as part of the initial design stage. Michelangelo is justifiably famous for his drawings, some of which (like those for the Julius II tomb and the Medici tombs) were studies for sculptural projects. He also used wax and clay models, both as part of the design process and as records for his studio assistants. The brief, infamous meeting of Michelangelo and Giambologna in Rome, when the latter was still a young man just beginning his career, and the former, an old man of seventy-five, at the end of one of the most illustrious careers of all time, revolved around the question of models. According to Baldinucci, when Giambologna brought one of his wax sketches to show Michelangelo, the master destroyed the little figure, saying: "Now, go off and learn to model first, before trying to finish anything."[42]

The means by which fifteenth-century sculptors developed their ideas are less clear. Although it is often assumed that they used both drawings and models, little evidence for either activity survives. We are fortunate to have some important *bozzetti* for sculpture, some preserved in the original wax and clay, others surviving because they were cast as small bronzes. The role played by two-dimensional designs is harder to determine, although once again, there are scattered bits of visual and literary testimony to suggest that sculptors in the quattrocento used drawings as frequently as models. In the case of Mino da Fiesole, the evidence is found not

only in a series of drawings that survive on the walls of his Florentine home, but also in his documented commissions where, with striking regularity, the contract refers to a drawing or model on paper. But one could deduce the use of drawings in the case of Mino's St. Jerome reliefs even without any written evidence. One need only look at the figures in both the *Miracle of the Lion* and the *Miracle of the Ass* to recognize that the sculptor was using the same drawings more than once and that, on occasion, he reversed them. The pose used for the figure of St. Augustine, with arm and head raised upward, reappears in later works by the sculptor, but not always facing in the same direction and never for the same figure. Two striking examples are the figures of *Saints Peter and Paul* from the ciborium he created for Santa Maria Maggiore, Rome (Fig. 6).

To recognize the process of design is also to begin to understand the configuration and functioning of the workshop. Between 1459 and 1464, Mino da Fiesole produced two important monuments with forty different reliefs. In order to accomplish these tasks Mino, like Giambologna and Bernini after him, employed numerous assistants. In his case, the designs served to guide his employees; for Giambologna and Bernini, *bozzetti* and *modelli* served the same purpose. In looking at these models, one must try to read forward to the artist's final intentions, but equally when looking at a finished work, one must try to read backwards through the process of creation.

As viewers we tend to ask ourselves first about subject, then about the artist, the date, and now, perhaps, about the purpose and the creative process, often forgetting to inquire about the essential feature of any work of sculpture: its medium. During the

period under consideration here, sculpture was produced in marble, bronze, wood, gold, silver, ivory, and less expensive materials, such as terracotta and wax. The choice of medium was related to the purpose and meaning of the work, and it also irrevocably shaped its scale, form, and style. A marble statue or relief, by definition, calls to mind the tradition of classical sculpture. Marble is heavier than bronze and thus it has less tensile strength, allowing a much more limited extension into space than with bronze. At least during the Renaissance and Baroque periods, few could afford to make monumental statues of gold or silver. On the other hand, gold was not used for humble subjects; marble was not fine enough for sacred vessels; and bronze was an ideal material for small, highly refined objects that were easily replicated. Thus, each material came with its own set of preconditions and traditions. One must assume that artists and their patrons were aware of these limits and, indeed, the decorum of their materials.

With the exception of the marble reliefs by Mino da Fiesole and Giuseppe Mazzuoli, all the works in this exhibition are in bronze or terracotta. The relatively small scale of these statues creates an illusion of similarity, one that is incorrect. Whereas the small bronze statuettes, whatever their intended function, are completed works of art, the terracottas are *bozzetti* and *modelli*, made by the artists as studies or designs for larger works in marble and bronze, or, as is the case in the work by Tribolo, a "copy" of a marble sculpture. They anticipate or reflect other works, larger in scale and of more expensive materials.

Sculpture, whatever the particulars of its genesis or medium, exists in three-dimensional space. Compared to painting, it is extraordinarily difficult

Figure 6
Mino da Fiesole, *Alma Fides,* 1459-1461.
Marble relief with gilding, 91 x 81 cm.
From High Altar Ciborium, Santa Maria Maggiore,
Aula Capitolare of Santa Maria Maggiore, Rome.

to discuss the history of sculpture using only photographs, because sculpture is deprived of its central feature, its plasticity, when reproduced in two dimensions. This exhibition, therefore, allows the viewer to think not merely about subject and style but about material, scale, weight, and process, literally the tactile reality of sculpture. Marble is cold to the touch; bronze catches the light, flickering in and out of the shadows created by its twisting forms and the viewer's motion; terracotta is molded, preserving all the immediacy of its purpose. But in every instance, these Renaissance and Baroque sculptors took as their subject the human form.

It is this truth, the centrality of the human figure in Western sculpture, that allows us, across the barriers of changes in taste, of religious differences, even of inherent disinterest, to appreciate these images. They are like us: they represent us, in space and in motion, as we would ideally like to see our human forms. So now, as you walk through the sculptureless streets of late twentieth-century America, imagine how our world would look, if only we were once again surrounded by these super-human, heroic depictions of our better selves.

Shelley E. Zuraw
Curator of the Exhibition
Assistant Professor of Art History,
University of Georgia

Endnotes

[1] The quotation in the title is taken from a sonnet written by Michelangelo in 1545/46 and translated by Avery, 1984, 172:

When godlike art has, with superior thought,
The limbs and motions in idea conceived,
A simple form, in humble clay achieved,
Is the first offering into being brought:
Then stroke on stroke from out of the living rock
Its promised work the practised chisel brings,
And into life a form so graceful springs,
That none can fear for it time's rudest shock.

The sonnet, of which there are two versions (see Cesare Guasti, *Le rime di Michelangelo Buonarroti*, Florence, 1863, 171-2) is more commonly known in its earlier form and is usually rather differently translated; Creighton Gilbert, *Complete Poems and Selected Letters of Michelangelo*, New York, 1963, 132, no. 234; *The Poetry of Michelangelo*, trans. James M. Saslow, New Haven and London, 1991, 400-1, no. 236.

[2] One might add here that the exception proves the rule: the extraordinary debate over the Arthur Ashe statue for Monument Avenue in Richmond, Virginia only emphasizes how infrequently we concern ourselves today with public statuary.

[3] For a broad overview of Renaissance and Baroque sculpture in Italy, see Pope-Hennessy, 1985 and Pope-Hennessy, 1986. On the Roman Baroque, see Montagu, 1989. More specific, but still introductory studies of Italian sculpture from each century are found in the series *Storia dell'Arte in Italia* published by UTET: Francesco Negri Arnoldi, *La scultura del quattrocento*, Turin, 1994; Giovanni Mariacher, *La scultura del cinquecento*, Turin, 1987; Nava Cellini. 1982.

[4] On the influence of the antique see, among numerous studies, Phyllis Pray Bober and Ruth Rubinstein, *Renaissance Artists and Antique Sculpture. A Handbook of Sources*, Oxford, 1986, esp. 31-40; Roberto Weiss, *The Renaissance Dicovery of Classical Antiquity*, Oxford, 1969.

[5] The most recent treatment of Michelangelo's myth is Paul Barolsky, *The Faun in the Garden. Michelangelo and the Poetic Origins of Italian Renaissance Art*, University Park, PA, 1994; from among the numerous related studies, see Martin Kemp, "The 'Super-Artist' as Genius: The Sixteenth-Century View," *Genius: The History of an Idea*, ed. P. Murray, Oxford, 1989, 32-53; Eugenio Battisti, "La critica a Michelangelo prima del Vasari," *Rinascimento*, v, 1954, 117-32; and idem, "La critica a Michelangelo dopo il Vasari," *Rinascimento*, VII, 1956, 135-57. On his social position, see Wallace, 1994, 1-8; and, for artists generally, see Martin Wackernagel, *The World of the Florentine Renaissance Artist*, trans. A. Luchs, Princeton, 1981.

[6] Tribolo's copies of *Night, Day, Dawn,* and *Dusk* are mentioned by Vasari: Vasari-Milanesi, VI, 66; whose description is often linked with the three clay figures in the Museo Nazionale, Bargello, Florence of *Day, Dawn,* and *Dusk*. On these models, see de Tolnay, 1948, 155. Another famous example of the influence of the figures from the Medici Chapel are the drawings done by Jacopo Tintoretto; see *Jacopo Tintoretto 1519-1594. Il grande collezionismo mediceo*, exh. cat., ed. Marco Chiarini et al., Florence, 1994, 17-18, although his drawings seem to have been done after casts made, according to Ridolfi, by Daniele da Volterra in 1557.

[7] The modern literature on Italian bronzes began with Bode's publication in 1907 which has recently been republished in English: Bode, 1980. On the collecting of bronzes, see Anthony Radcliffe, *European Bronze Statuettes*, London, 1966; and Manfred Leithe-Jasper, *Renaissance Master Bronzes from the Collection of the Kunsthistorisches Museum, Vienna*, exh. cat., Washington D.C., 1986; Pollaiuolo's *Hercules and Anteus* (Museo Nazionale, Bargello, Florence) represents an important example of an *all'antica* bronze displayed as a table piece: see Martin Kemp in *Circa 1492: Art in the Age of Exploration*, exh. cat., ed. Jay A. Levenson, Washington D.C., 1991, 263-4, no. 162.

[8] Sarah Blake Wilk, "La decorazione cinquecentesca della cappella dell'Arca di S. Antonio," *La scultura del Santo a Padova* [Fonti e studi per la storia del Santo a Padova, Studi 4], ed. Giovanni Lorenzoni, Vicenza, 1984, 166-8, figs. 302-5. The bronze *Faith* in the Palazzo Venezia is not directly copied from the statue of *Faith* in the Santo, which was installed in the choir in 1597 along with three other bronze figures of Virtues. Rather, the statuette appears to combine formal aspects of several of the bronze Virtues: *Hope, Faith,* and *Temperance*. It is worth noting that a second version of this same statuette is recorded in the collection of Michael Hall, New York, NY, in 1968(?). There the figure is paired, oddly enough, with a bronze depiction of Mars: for these statuettes see the Kunsthistorisches Institut in Florenz Fototeca, no. 223582 and 461815.

[9] Santangelo, 1954, 78-9, fig. 87; Barberini, 1991, 47-8; Weil, 1974, passim, esp. 80-1. The marble *Angel with the Superscription* was carved between 1668 and 1669 (Fig. 2); when completed Pope Clement IX decided to send it and its companion, *Angel with the Crown of Thorns*, to Pistoia. In 1729, however, the two sculptures were given by Prospero Bernini to the Roman church of Sant'Andrea delle Fratte. The statue of the *Angel with the Superscription* on the bridge is a variant made by Giulio Cartari, Bernini's assistant, in 1670. See also Cardilli Alloisi, 1988, 68-73. For the technique and history of *bozzetti*, see below.

[10] Barberini, 1991, 61.

[11] Once attributed to Duquesnoy, the two reliefs are now given to Mazzuoli and dated ca. 1694 on the basis of their similarities with the large marble relief of the *Vision of the Blessed Ambrogio Sansedoni* in the chapel of the Palazzo Sansedoni, Siena: Pansecchi, 1959, 41.

[12] On Susini, see Katherine Watson, *Pietro Tacca. Successor to Giovanni Bologna,* (Garland), New York and London, 1983, 45-48; Avery, 1987, 227-8. For a similar crucifix, mounted on a bronze hill of Golgotha and also attributed to Susini, see *Renaissance Bronzes in American Collections*, exh. cat., Smith College Museum of Art, Northampton, 1964, no. 25; Watson and Avery, 1973, 493-507, esp. 504. The type, depicting the Crucified Christ alive was first used by Giambologna for the ciborium over the high altar in Santissima Annunziata, Florence, in 1578, and was reproduced regularly by Susini, one of whose assistants even specialized in making them; see Avery, 1987, 202, 264.

[13] Montagu, 1996, esp. 1-18.

[14] Santangelo, 1954, 91, fig. 104, attributes the relief to Giuseppe Rusconi; the correct attribution to Algardi, based on a preparatory drawing in the Hermitage, was made by Jennifer Montagu, 1985, I, 24-7, II, 387-8. The framed and gilded terracotta is recorded in the chambers of the English Jesuit Father Thorpse in 1791. See also Barberini, 1991, 33.

[15] The altar complex honoring St. Ignatius was designed by Andrea Pozzo in 1695; he reused the urn, commissioned in 1629 and installed in 1637, from an earlier altar on the site: Levy, 1990, 46-61; idem, "A canonical work of an uncanonical era: re-reading the chapel of St. Ignatius (1695-1699) in the Gesù of Rome," Ph.D. dissertation, Princeton University, 1993, 44-76.

[16] Avery and Radcliffe, 1978, 165, no. 137 and 164, no. 136.

[17] For the statuette of Apollo, 1573-5, see Avery and Radcliffe, 1978, 88, no. 36. On the relation of the *Peasant Leaning on a Staff* to an ancient marble statue of a *Shepherd resting*, see Avery, 1987, 47, fig. 43.

[18] Avery, 1987, 43-50; for an illustration of Dürer's *The Bagpiper*, fig. 36.

[19] Anthea Brook, "Sixteenth Century 'Genre' Statuary in Medici Gardens and Giambologna's Fontana del Villano," *Boboli 90. Atti del convegno internazionale di studi per la salvaguardia e la valorizzazione del giardino,*

2 vols., Florence, 1991, II, 113-130; and Detlef Heikamp, "'Villani' di marmo in giardino," *Il giardino d'Europa. Pratolino come modello nella cultura europea*, Milan, 1986, 61-66.

[20] A second version of each of these statuettes: *Peasant Leaning on a Staff*, now on the art market (no. 138) and *Seated Bagpiper*, Museo Nazionale, Bargello, Florence (no. 135) are also catalogued in Avery and Radcliffe, 1978, 164-165; see also Avery, 1987, 266. In Watson and Avery, 1973, 502, versions of these two bronzes are attributed to Pietro Tacca.

[21] This *bozzetto* has traditionally been attributed to Bernini: see Santangelo, 1954, 80-81, fig. 89, where it is associated with Bernini's designs for the *Moro Fountain* in the Piazza Navona, although he notes that this same model has also been linked with the *Triton Fountain* in the Piazza Barberini. Recent research has led to the reassigning of the model to Ferrata and association of this *bozzetto* with the *Neptune Fountain* in Queluz, Portugal; this information was graciously sent to the Palazzo Venezia by Jennifer Montagu.

[22] For tritons, see *The Oxford Classical Dictionary*, 2nd ed., Oxford, 1970, 1095; *The Oxford Guide to Classical Mythology in the Arts, 1300-1990s*, ed. Jane Davidson Reid, 2 vols., New York and Oxford, 1993, II, 1038-1040.

[23] Giambologna had already employed the same subject for a fountain, where the water was seemingly blown from the long conch shell held aloft by the triton. This same idea was adopted by both Bernini and Ferrata. On Giambologna's Triton fountain, see Avery, 1987, 210. Bernini depicted tritons several times: these include the *Neptune and Triton*, for the Villa Montalto, now in the Victoria and Albert Museum, London, from ca. 1620-1621; the *Triton Fountain* done for Urban VIII Barberini in 1642-1643; and the so-called Fountain of the Moor, done for Innocent X Pamphili, from 1653. A study for the head of the Moor is also in the Palazzo Venezia collection; see Barberini, 1991, 40. It shares with Ferrata's model the windblown locks of hair, the rather thick features, and the deep eye-sockets. See D'Onofrio, 1957, 65-77, 191-195; Androsov, 1991, 60.

[24] A different aspect of this issue is represented by the *bozzetto* in the exhibition by Melchiore Caffà for the figure of *St. Rosa of Lima* (Cat. No. 17). Designed before Bernini's sculpture of *The Blessed Ludovica Albertoni*, the *St. Rosa* anticipates some of the dramatic effects that we typically associate with Bernini. See Di Gioia, 1987, 39-53.

[25] Leonardo da Vinci, MS Bibliothèque Nationale (BN 2038), 27r, Paris, as quoted in Kenneth D. Keele, *Leonardo da Vinci's Elements of the Science of Man*, New York and London, 1983, 267.

[26] Mimi Cazort, "Wax Anatomical Models as Teaching Devices in Eighteenth-Century Bologna and Florence," *Drawing*, IV, 1982/83, 5-8.

[27] Beth Holman, "Verrocchio's Marsyas and Renaissance Anatomy," *Marsyas: Studies in the History of Art*, XIX, 1978, 1-10; Francis Haskell and Nicholas Penny, *Taste and the Antique. The Lure of Classical Sculpture, 1500-1900*, New Haven and London, 1981, 262-263; and Francesco Caglioti, "Due 'restauratori' per le antichità dei primi Medici: Mino da Fiesole, Andrea del Verrocchio e il 'Marsia rosso' degli Uffizi, II," *Prospettiva*, nos. 73-74, 1994, 74-96.

[28] Frederick Hartt, "Michelangelo in Heaven," *artibus et historiae*, XIII, no. 26, 1992, 191-209.

[29] On the Flemish sculptor, see Udo Kultermann, *Gabriel Grupello*, Berlin, 1968. The *Écorché* makes an interesting comparison with his bronze statuette of *St. Bartholomew* ca. 1710-1716 in the Bayerisches Nationalmuseum, Munich; see ibid., 151-152, fig. 83.

[30] Compare this bronze with the much earlier flayed man or *écorché* depicted in *The Academy*, an engraving by Battista da Parma after Stradano; see Avery 1984, fig. 1. The distinction between living people and the skeletal and muscled models that they study is undercut by the seemingly lifelike pose of the skeleton in the foreground and the equally activated pose of the *écorché*.

[31] The third major type, the full-figure portrait, is less common. First used for tomb effigies, portrayals of the entire body were also used for public sculpture with political connotations; examples include equestrian monuments, ruler portraits, and images of the seated pope.

[32] On Mino da Fiesole's early portraits, see Shelley Zuraw, "The Medici Portraits of Mino da Fiesole," *Piero de'Medici 'il Gottoso' (1416-1469): Kunst im Dienste der Mediceer*, eds. Andreas Beyer and Bruce Boucher, Berlin, 1993, 317-339. On Bernini's portraits, see Wittkower, 1955, 13-19. See also the series of article on portraits by Irving Lavin: Lavin, 1968, 223-248; Irving Lavin, "On the Source and Meaning of the Renaissance Portrait Bust," *Art Quarterly*, XXXIII, 1970, 207-26; idem, "On Illusion and Allusion in Italian Sixteenth-Century Portrait Busts," *Proceedings of the American Philosophical Society*, CXIX, 1975, 353-362.

[33] A recent discussion of this history is presented by Irving Lavin, "Pisanello and the Invention of the Renaissance Medal," *Italienische Frührenaissance und nordeuropäisches Spätmittelalter. Kunst der frühen Neuzeit im europäischen Zusammenhang*, ed. Joachim Poeschke, Munich, 1993, 67-84. Michelangelo's view of portraiture is discussed in David Summers, *Michelangelo and the Language of Art*, Princeton, 1981, 216-217.

[34] Bimm, 1974, 72-76.

[35] Kruft and Larsson, 1968, 130-135; Tratz, 1988, 468-469; John T. Spike, "The Court Portrait: Notes on Four Papal Portrait Busts in Bronze," *Baroque Portraiture in Italy: Works from North American Collections*, exh. cat., Sarasota, FL, 1984, 34-41.

[36] On the replication of papal coins and medals, see Montagu, 1996, 73-75.

[37] The famous study by Brinckmann, 1923-1926 continues to be a useful introduction. The important newer studies on models commenced with Irving Lavin, 1967; and include Avery, 1984; and Montagu, 1986.

[38] See above, note 9; and also Mezzatesta, 1982; and Androsov, 1991, 69, no. 22.

[39] Lavin, 1978, 398-405.

[40] Wallace, 1994, passim, but note esp. 88-92, on models for the chapel.

[41] For discussions of the history and technique of *bozzetti*, see above note 39 and Barberini, 1991, 20-30.

[42] "Or va prima ad imparare a bozzare e poi a finire": Baldinucci, 1846, II, 556. The translation comes from Avery, 1978, 3.

Catalogue of the Exhibition

All works are in the collection of the Museo Nazionale del Palazzo di Venezia, Rome.

Mino da Fiesole

(Poppi 1429-1484 Florence)

1

St. Jerome in the Wilderness and in His Study, 1461-1464

Carrara marble

110 x 61.6 x ca. 8.5 cm.

Inv. MAI 364

Provenance: Santa Maria Maggiore, Rome

Mino da Fiesole, one of the most prolific and well-traveled Florentine sculptors of the late fifteenth century, began his career in the service of the powerful Medici family. During two sojourns in Rome (ca. 1458-1464; 1474-1480) he extended his Florentine training by incorporating ideas and forms drawn from the illustrious classical and early Christian artistic heritage of the eternal city. The four marble reliefs in the Palazzo Venezia come from a dismantled altar dedicated to the early Christian Doctor of the Church, St. Jerome (d.420), which stood in the Roman basilica of Santa Maria Maggiore. Both the altar and the slightly earlier ciborium (1459-1461; Caglioti, 1987, 15-32) over the high altar of the same basilica were executed for the French Cardinal Guillaume d'Estouteville (1421-1483). The two series of marble narrative reliefs associated with these projects reflect a fascinating blend of antique and modern sources. When Mino returned to Florence in 1464, he pro-

duced a series of tombs, altars, and sacrament tabernacles that clearly reveal his synthesis of the new Roman style with the traditions embodied in the work of his Florentine contemporaries Desiderio da Settignano and Antonio Rossellino. Thus, Mino's career, evenly divided between the two important political and artistic centers of Florence and Rome, anticipates the convergence of ideas that generated the High Renaissance a quarter of a century later.

The altar of St. Jerome honors a patristic saint, famed throughout the Middle Ages as the translator of the Bible from Greek into Latin, whose vast intellectual learning opened a new chapter in the history of Christian theology (Rice, 1985, passim). By the time of the Renaissance, St. Jerome had become the spiritual model for humanist scholars searching to reconcile their Christian faith with a profound fascination with classical, pagan studies. St. Jerome founded a monastery in Bethlehem, the city of Christ's birth, and it was there that the saint was buried. After the conquest of the city by the Turks in 1244, the saint's remains were miraculously transferred to Rome, the new Jerusalem, and specifically, to Santa Maria Maggiore, considered to be the new Bethlehem due to the presence of the sacred relic of the manger in which Christ was sheltered after His birth. By the end of the fourteenth century, St. Jerome's relics were located *sub grata ferrea*, in front of the Chapel of the Crib. In the early fifteenth century an expensive silver urn was purchased for the saint's remains (Biasiotti, 1920, 237-244). Cardinal d'Estouteville's new altar, undertaken in the middle of the century, was built over the same spot and presumably housed this same urn (for a plan of

the fifteenth-century basilica, see Schwager, 1961, Figs. 241 and 242).

The provenance of the four reliefs from the Palazzo Venezia can be traced back to the Marian basilica in Rome. In 1586 Pope Sixtus V (1585-1590) dismantled the fifteenth-century altar to make way for his funerary chapel. In the center of his new chapel, the pope installed the famous fourteenth-century crèche and, in a small atrium chapel, he built a new altar dedicated to St. Jerome. The four narrative reliefs were transported to the pope's residence, the Villa Peretti or Montalto located on the Esquiline Hill. From there, the reliefs were transferred to the Cappella del Palazzo Strozzi presso le Stimmate. Earlier in this century they were briefly housed in the R. Museo Artistico Industriale di Roma, from whence they were transferred to the Palazzo Venezia in the late 1950s (Biasiotti, 1915, 29-30; Serra, 1933-1934, 582).

The four reliefs depict events from the life of the early Christian saint. In the first, the saint is shown twice, kneeling before his cave in the wilderness as he beats his chest in penitence, and seated in his study, pointing to his translation of the Bible. Two related reliefs represent *St. Jerome Healing the Lion* and *The Lion Returning the Stolen Beasts*. According to the saint's legend, when a wounded lion came to him for help, Jerome, without fear, took a thorn from the lion's paw and thus tamed the wild beast. The lion was then assigned the task of guarding the monastery's animals, but when it fell asleep, they were stolen. Jerome made the lion take the place of the donkey and work as a beast of burden, a trial that it bore with dignity until, miraculously, it recovered the animals and returned them to the saint. The last relief, often mistakenly identified as St. Jerome in his study,

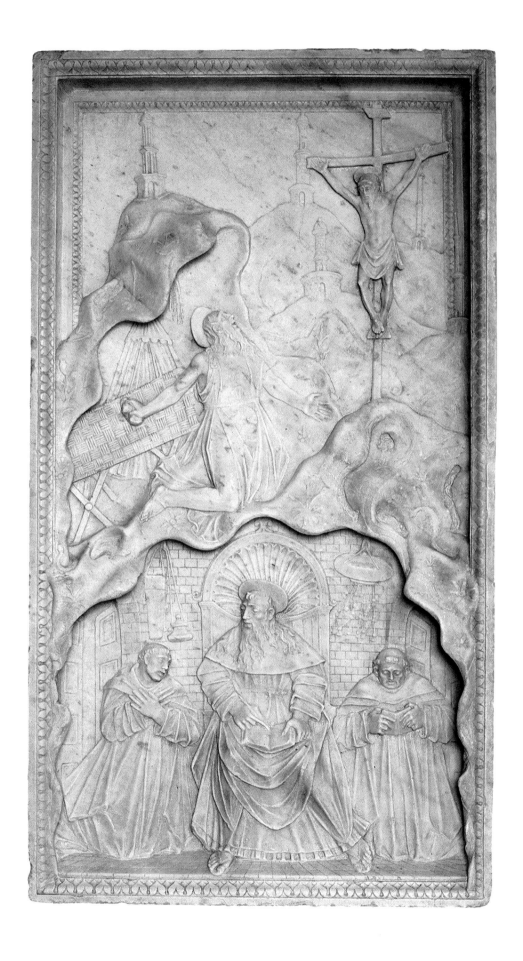

Mino da Fiesole

(Poppi 1429-1484 Florence)

2

St. Jerome Healing the Lion, 1461-1464

Carrara marble

109.5 x 62 x ca. 8.5 cm.

Inv. MAI 361

Provenance: Santa Maria

Maggiore, Rome

depicts *The Vision of St. Augustine*. This is a posthumous miracle in which St. Jerome and St. John the Baptist appear together in a mandorla to St. Augustine, seated in his study, to tell him of the death of St. Jerome (the correct identification of this scene was made by Antin, 1968; see Roberts, 1959, and Jolly, 1983).

These reliefs have been splendidly restored for this exhibition. But the damage and consequent repairs resulting from the dismantling of the altar and the various peregrinations of its remaining pieces are also visible for the first time. Most significant are the replacements added in the center of the relief of *The Lion Returning the Stolen Beasts* and to the right side of *St. Jerome Healing the Lion*, along the bottom of the break that cuts across the entire relief. The first relief, *St. Jerome in the Wilderness and in His Study*, is in the best condition; unlike the other reliefs, the back was not trimmed. The extremely elaborate still-life in the relief of *The Vision of St. Augustine* includes books, a miter, and a table with free-standing legs; the precision of the carving is without parallel in fifteenth-century sculpture.

For most of this century, the attribution of these reliefs to Mino da Fiesole remained problematic. Writing in the sixteenth century, Giorgio Vasari mentioned the altar of St. Jerome as a work by Mino da Fiesole, but he also assigned a series of related works, including the Santa Maria Maggiore high altar ciborium, to a Neapolitan artist whom he named Mino del Reame. Because of the apparent overlap of chronology and style between these two sculptors, both named Mino, many of Mino da Fiesole's Roman works from the 1450s and 1460s were wrongly attributed to this second Mino, now recognized as Vasari's invention (on this problem see Langton Douglas, 1945). A third possibility, that these works were done by a documented Neapolitan sculptor named Jacopo della Pila, was supported by Sciolla (1970, 25). Only recently has the attribution to Mino da Fiesole of all these sculptures, including the St. Jerome reliefs, been universally accepted by scholars.

Arising from the question of authorship came the issue of dating. Those scholars who wished to retain Mino da Fiesole as the sculptor of the St. Jerome reliefs often resorted to shifting them to Mino's later sojourn in Rome, from 1474 to 1480, in order to avoid proximity to the high altar ciborium and other works associated with Mino del Reame. Because Panvinio includes Bishop of Ostia among the patron's titles, it is generally assumed that the altar was begun after 1461, the year Cardinal d'Estouteville was awarded that office. Two manuscripts from the 1460s mention the altar. The first, a treatise concerning the Virgin dedicated to Cardinal d'Estouteville, was written in 1464, thus establishing a *terminus ante quem* (Wolf, 1990, 212); the second, the *Theotócon* of Domenico da Corella

(1403-1483) was presented to Piero de' Medici in 1468 (Biasiotti, 1920, 240). Further evidence for the chronology and meaning of the altar is found in two papal bulls dated 1459 and 1464, which instituted indulgences for those who visited the shrine of the saint. Both bulls were displayed on or close to the actual altar; the text of one of these, cut in stone, remains in the basilica of Santa Maria Maggiore, near the entrance to the Chapel of Sixtus V (Barbier de Montault, 1893, 106-118).

The four reliefs can be related stylistically to documented works completed by Mino da Fiesole shortly after his return to Florence in 1464. The peculiar *contrapposto* pose employed for both seated and standing figures, with one leg sharply projected to the side, seems to be Mino's unique adaptation of a classical stance. The numerous linear, regular folds are also typical of Mino's style throughout his career. Equally characteristic are the facial types, especially the youthful beardless faces and the elderly male heads with open mouths. Indeed, the repetition of faces and poses was standard practice in Mino's workshop, both in Rome and Florence. The two works completed by Mino da Fiesole for Cardinal d'Estouteville, the altar of St. Jerome and the high altar ciborium, were both complex and elaborate structures; in order to complete them in such a short time Mino must have had numerous assistants. The noticeable swings in quality—one might compare the sophisticated execution of St. Jerome with the summary treatment of some of his frightened companions in the miracles of the lion—confirms the presence of several hands in the creation of these reliefs.

Unfortunately, the evidence for the original form of the St. Jerome altar is

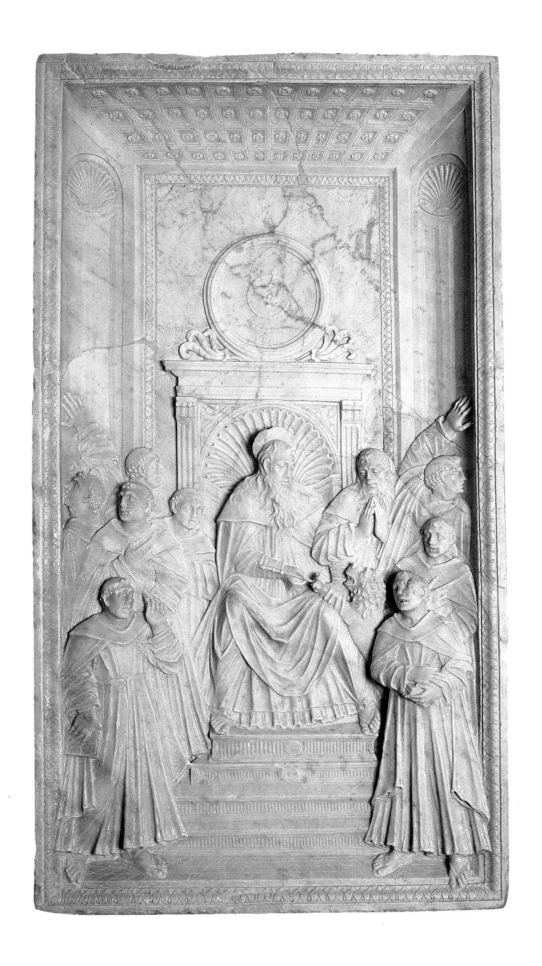

43

Mino da Fiesole
(Poppi 1429-1484 Florence)

3

The Lion Returning the Stolen Beasts, 1461-1464

Carrara marble

110 x 62 x ca. 8.5 cm.

Inv. MAI 362

Provenance: Santa Maria Maggiore, Rome

extremely limited. As Caglioti notes, it is even impossible to verify that only four narrative reliefs existed on the altar (Caglioti, 1991, 32-34). Vasari, who says that the altar included a portrait of the patron, provides no further information about its appearance (Vasari-Milanesi, III, 117-118). By the eighteenth century when the history of the relics and its altar was described by Giuseppe Bianchini, only the four reliefs known today were identified as part of the structure. Biasiotti's reconstruction of the ensemble—a double-sided altarpiece with two reliefs on either side—does not include the portrait and fails to account for the principal purpose of the structure, which was to house the relics of the saint. A tenta-

tive reconstruction of the altar can be attempted despite the lacunae. In addition to the fragments remaining in Santa Maria Maggiore—the pilasters now located on the altar of St. Jerome built by Sistine V, and a carved inscription of a 1464 papal bull—two other extant sculptures can be connected with the altar. The first (Fig. 1) is a relief bust of the cardinal patron (Metropolitan Museum of Art, New York; see Callisen, 1936, 401-406); the second is a sculpted arch from the Kress Collection (Fig. 2). Its height, 110cm, is precisely that of the narrative reliefs (Lowe Art Gallery, Coral Gables, Florida; see Middeldorf, 1976, Fig. 55). Middeldorf connected the arch with the high altar ciborium, but the two small roundels

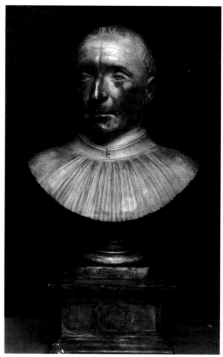

Figure 1
Mino da Fiesole,
Portrait Bust of Cardinal Guillaume d'Estouteville,
ca. 1460-1464
Marble, 33.3 cm (height)
Metropolitan Museum of Art, New York,
Bequest of Benjamin Altman, 1913, no. 14.40.674

Figure 2 Workshop of Mino da Fiesole,
Arch with Tondi of the Angel and Virgin of the Annunciation, 1461-1464
Marble, 110 x 208 cm (in two pieces).
The Lowe Art Museum; Gift of Samuel H. Kress Foundation

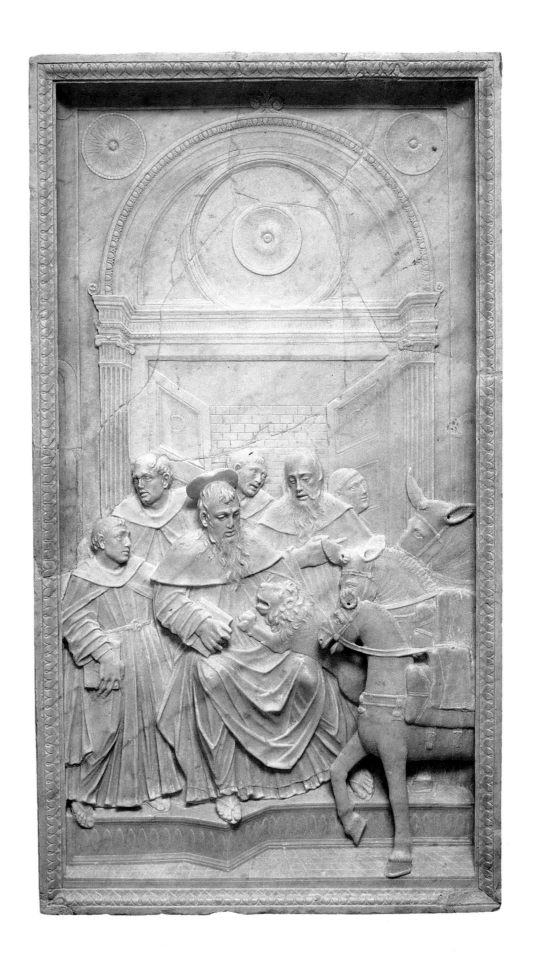

Mino da Fiesole

(Poppi 1429-1484 Florence)

4

The Vision of St. Augustine,
1461-1464

Carrara marble

110 x 61.5 x ca. 8.5 cm.

Inv. MAI 363

Provenance: Santa Maria
Maggiore, Rome

with depictions of the Angel and Virgin of the Annunciation in the spandrels repeat a subject already present on the ciborium and still extant in the basilica (Zuraw, 1993, 632-634).

The St. Jerome altar which, according to Panvinio, was surrounded by a metal grill, probably consisted of an altar table surmounted by an arch and set before a raised tabernacle containing the relics (Panvinio, Vat. Lat. 6781, fols. 150r-151v). A free-standing, two-story structure, it would have recalled a common type of medieval altar, in particular, two prominent examples that existed in Santa Maria Maggiore, one dedicated to three early Christian martyrs, the altar of the Relics, and another for the famous icon of the Virgin attributed to St. Luke (see Zander, 1984, Figs. 5-7).

The evocation of a medieval Roman form for the altar itself offers an important clue for the genesis of the entire project. The choice of monumental, marble narrative reliefs to decorate the structure depends on an equally important aspect of Rome's artistic legacy, the ancient remnants of her Imperial past. The St. Jerome reliefs, although not strictly classical in style, reveal the influence of Roman marble reliefs in their scale and medium. Indeed, Mino's extraordinary works invoke an entire genre of Roman relief sculpture that were still visible in Rome during the quattrocento, for example, on the three extant triumphal arches. On the other hand, the details of style derive from another source altogether, early Christian ivories. This is especially obvious in the double relief of *St. Jerome in the Wilderness and in His Study*, where the ground line that divides the scenes imitates a common solution used in these small scale works. By uniting the scale and public

character of Roman marble reliefs with the style and imagery drawn from early Christian ivories, Mino achieves an ideal amalgamation of Rome's two great inheritances—her imperial and patristic histories. This formal innovation parallels St. Jerome's own status as classical scholar and Christian saint. In honor of an early Christian saint and set in an early Christian basilica, the altar of St. Jerome exemplifies the goal of Roman quattrocento art, to recast the city's unique legacy in the service of her modern leaders, the pope and his cardinals.

SEZ

Bibliography: Fra Mariano da Firenze (Bulletti), 1931, 19; *Epistolae D. Hieronymi Stridoniensis,* 1565, I, n.p., 'Vita Divi Hieronymi'; Vasari-Milanesi, III, 41, 117-118; Panvinio, Cod. Vat. Lat. 6781, fols. 150r-151v; idem, *De praecipius urbis,* 1570, 242; Ugonio, 1588, 69; DeAngelis, 1621, 55-56; Bianchini, Ms. T86, fol. 26r; Müntz, 1882, 41; Venturi, 1888, 411-413; Gnoli, 1890, 103-106; Bode, 1892-1905, I, 123, IX, pl. 410; Fraschetti, 1901, 114; Angeli, 1904, 427-429; Angeli, 1905, 36-37; Venturi, 1908, 646-648; Marx, 1915, 55; Alazard, 1918, 76-78; Biasiotti, 1920, 240-242; Lanzoni, 1921, 383-390, 458-469; Lange, 1928, 45-46, 53-54; Schottmüller, 1930, 580; Ragghianti, 1938, 171; Riccoboni, 1942, 28; Valentiner, 1950, 84-85; Seymour, 1966, 156; Antin, 1968, 23-26; Golzio and Zander, 1968, 322; Sciolla, 1970, 25, 131-132, cat. no. 94; Zuraw, 1985, 185; Pope-Hennessy, 1985, 287; Ostrow, 1987, 13-14, 341-345; Caglioti, 1987, 26-27; *In corso d'opera,* 1988, 34; Mancinelli, 1988, 198; Poeschke, 1990, 143; Caglioti, 1991, 32-34 (with extensive bibliography); Gill, 1992, 108-115; Zuraw, 1992, 312-317; Zuraw, 1993, 150-198, and cat. 16, 576-588 (with extensive bibliography)

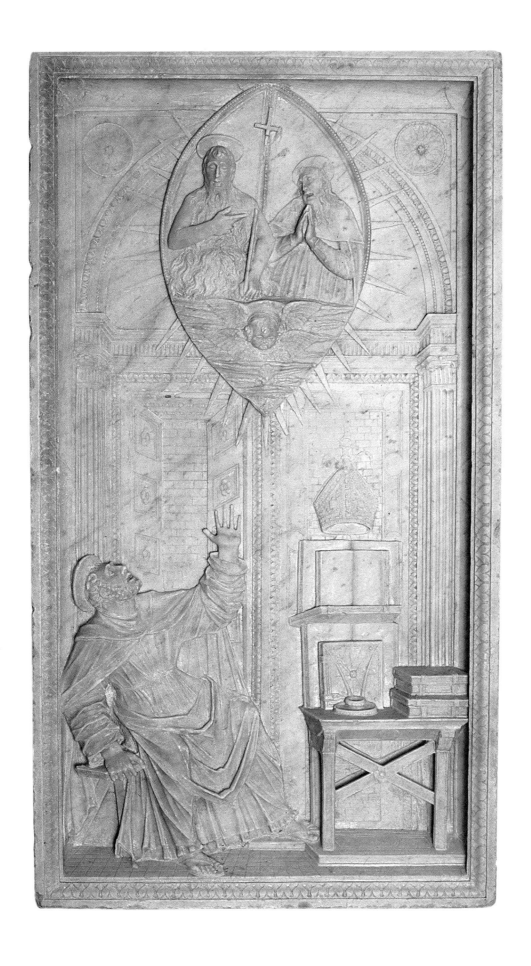

Nicolò Tribolo,

after Michelangelo

(Florence 1500-1558)

5

Night, after 1526

Reddish terracotta

29.5 x 31 x 11 cm.

Inv. 13441

Provenance: Cavaceppi

Collection; Gorga Collection

Attributed here to Tribolo, the clay piece is a study, of the highest quality, after Michelangelo's *Night* for the tomb of Giuliano de' Medici (Medici Chapel, San Lorenzo, Florence). Active in Tuscany, Tribolo collaborated with Michelangelo on the Medici tombs. Three other models by Tribolo, after Michelangelo's sculptures for the New Sacristy, depict *Dawn*, *Dusk*, and *Day* (inv. 313-314-315, h. 55 cm., Museo Nazionale del Bargello, Florence). Tribolo specialized in decorative sculpture but aspired to work on a monumental scale, as indicated by the fountains he designed for the Medici villa at Castello, near Florence.

To date, no contemporary reference to this terracotta, which may have served as a model for a small bronze, has been found (see note 6 in Zuraw), and the evidence as a whole is too vague to support a firm attribution. Nevertheless, the later history of the model provides one, small tantalizing clue: around 1770 a reference to the terracotta appears in a bill of sale written by the sculptor, restorer, and collector Bartolomeo Cavaceppi, who describes it as follows: "*Un bozzetto del 'Crepuscolo' cioè una don[n]a che sta al Deposito de Medici à Firenze opera di Michelangelo.*" The attribution to Michelangelo persisted in later inventories until the work entered the Gorga Collection. We do not know how Cavaceppi, who owned many clay models, amassed his collection, but one can easily imagine that, because a great part of the collection consisted of works by Roman sculptors, he purchased them directly from the heirs or students of the sculptors themselves. We know of Cavaceppi's rich collection thanks to the admiration of none other than Winckelmann, who claims to have seen several models after Michelangelo's works, including this one now in the Palazzo Venezia.

MGB

Bibliography: Barberini and Gasparri, 1994, 129

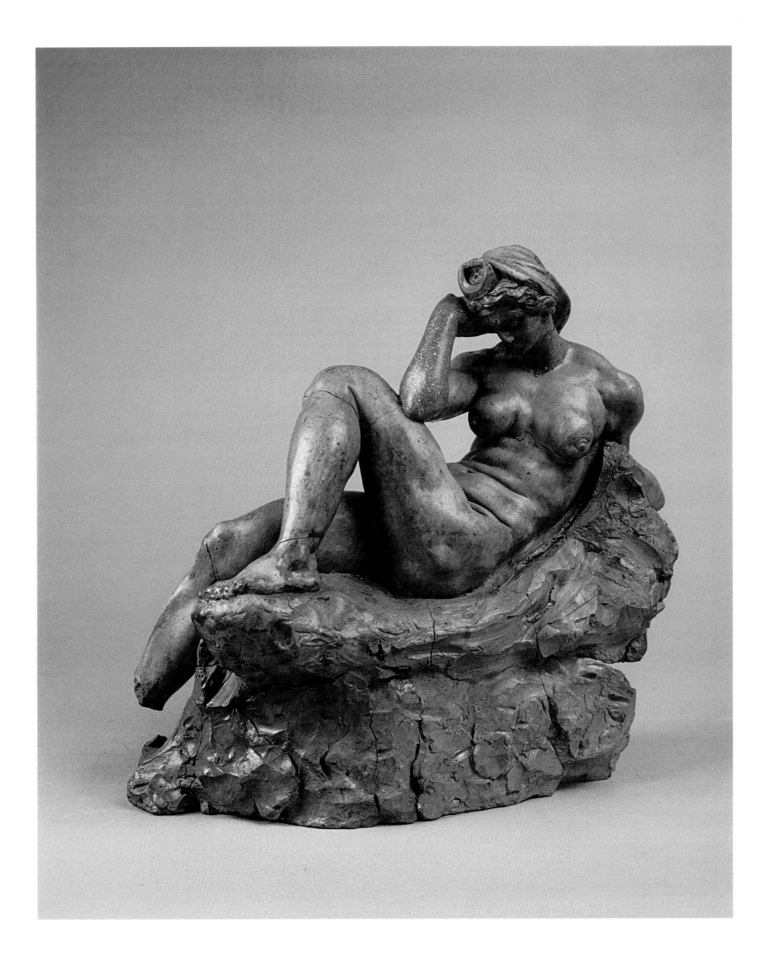

Tiziano Aspetti
(Padua 1565-Venice 1604)

6

Allegorical Figure of Faith (?),
ca. 1593
Bronze with warm brown
natural patina, black lacquer
47 cm.
Inv. PV 10784
Provenance: Gift of Giacinto Auriti
1963, no. 15
Exhibitions: *Italian Bronze Statuettes*
(London, Victoria and Albert
Museum, 1961, no. 169); *Meesters van
het brons der Italiaanse Renaissance*
(Amsterdam, Rijksmuseum, 1961-
1962, no. 163); *Bronzetti italiani del
rinascimento* (Florence, Palazzo
Strozzi, 1962, no. 161)

Tiziano Aspetti's authorship of the bronze statuette in the Palazzo Venezia is certain, but the lovely female figure's identity is not. She is, however, not without attributes. She holds a book and a small disc, possibly a host or the fragment of a chalice, and she rests her right foot upon a small turtle. Moreover, it is worth noting that the figure is soberly clothed. She wears a type of garment rarely seen on Aspetti's other female figures, and this fact suggests that the figure represents a religious allegory or a virtue.

The small bronze has long been compared to the four *Cardinal Virtues,* originally conceived for the altar of St. Anthony in the basilica of St. Anthony in Padua (Il Santo), but actually placed on the balustrade surrounding the high altar of that church. The comparison was first proposed in exhibition catalogues from 1961 (see *Italian Bronze Statuettes,* London, 1961, no. 169), where the *Allegorical Figure* in the Palazzo Venezia was described as a smaller version of one of the four *Virtues* that Aspetti made for the Santo. Pope-Hennessy (1963 and 1968, 172-198) disagreed; instead, he considered the figure independent and unrelated to those large bronzes.

While correct to observe differences between the *Allegorical Figure* and the *Virtues* in Padua, especially the mannered elongation of the bodies and their accentuated movement, it is also worth noting the statuette's similarities with a group of other sculptures for the same church: two *Candle-Bearing Angels* and *Saints Anthony, Louis of Toulouse, and Bonaventure.* In the latter works, as in the bronze from the Palazzo Venezia, movement is fairly restrained and figural proportions are much more normative. Perhaps, then, the *Allegorical Figure* may be assigned the same date as the great bronzes of Padua, that is, around 1593. A copy, including even the same kind of base, exists in the Worcester Art Museum, Worcester, Massachusetts (*Bulletin of the Worcester Art Museum,* IX, 1919, 61, n. 4)

PC

Bibliography: Planiscig, 1931, no. 15; Santangelo, 1964, 18, XIV; Pope-Hennessy, 1963 and 1968, 172-198.

Giulio dal Moro
(Verona 1555-Venice 1616)

7

The Savior, 1616
Bronze, solid cast, with
black opaque lacquer
47.5 cm.
Inv. PV 9307
Provenance: Gift of Benito Mussolini
1934; *Cittadini e industrie milanesi* 1934;
Alfredo Barsanti Collection, no. 80
Exhibitions: *Italian Bronze Statuettes*
(London, Victoria and Albert Museum,
1961, no. 158); *Meesters van het brons
der Italiaanse Renaissance* (Amsterdam,
Rijksmuseum, 1961-1962, no. 157);
Bronzetti italiani del rinascimento
(Florence, Palazzo Strozzi, 1962, no. 155)

"IVLIVS MAVRVS VERONENSIS SCULP-
TOR PICTOR ET ARCHITECTVS F." is
the inscription placed by Giulio
dal Moro, the artist who made this small
bronze statuette in the Palazzo Venezia,
on the base of another figure of *The
Savior*, a marble statue located in the
church of San Salvatore in Venice. The
two works suggest how wide-ranging
the sculptor's artistic activity was.
Recent reconstructions of his career and
personality define Giulio dal Moro as a
court artist. Indeed, he produced a sig-
nificant number of sculptures and
paintings for the Doge's Palace in Venice,
where he worked alongside other artists
such as Veronese, Andrea Vicentino,

Alessandro Vittoria, and Girolamo
Campagna.

Late in his career, the period from
which *The Savior* from the Palazzo
Venezia must date, Giulio mainly
devoted himself to portraiture, a genre
which as a painter he had, in fact,
never neglected. It appears that upon
the death of Alessandro Vittoria in
1608, Giulio inherited the position of
official portrait sculptor to Venetian
society, turning out numerous busts in
his fashionable style and even exceed-
ing Campagna in the sheer quantity of
his production.

Recognizing the Venetian character
of *The Savior*, Pollak (1922, 117) attrib-
uted it to Danese Cattaneo on the basis
of a comparison with that artist's *Christ*
on the Jano Fregoso altar in the church
of Sant'Anastasia in Verona. The attri-
bution of *The Savior* to Giulio dal Moro
was first proposed by Santangelo (1955,
44), who noted its resemblance to a
marble statue of *The Savior* placed
above the entrance to the church of
Santa Maria del Giglio in Venice.
Giulio's authorship of the statuette was
recently confirmed by Comastri (1988,
87-97), who associated it with Giulio's
late work and dated it to 1616. As fur-
ther support for the attribution to
Giulio, Comastri also noted that images
of Christ appear with exceptional fre-
quency in the artist's *oeuvre*. Although
surely demanded by his patrons, such
images must have suited the artist, and,
in fact, his statues of *Christ the Savior*
appear in many Venetian churches.

Despite its small size, this hieratic
bronze statuette of *The Savior* in the
Palazzo Venezia is monumental in its
conception. Christ raises his arm in a
gesture of benediction similar to that of

a marble *Christ* above the altar in Santo
Stefano. His left hand may have once
held a banner, thus making Him,
despite the calm of His face and the
moving sadness of His eyes, a
Victorious Christ and not *Christus
patiens* or Suffering Christ. He is the
Resurrected Christ, who has triumphed
over death with a victory so complete
that He does not bear the usual stigma-
ta or wounds on His hands and His
side. Drapery hardly conceals the hero-
ic nudity of His body, and this fact,
together with the powerful proportions
of the forms, underscores the image's
classicizing intent.

It is worth noting a small and sug-
gestive detail. The work departs from
the strict frontality typical of depic-
tions of the Risen Christ: the head
bends to the left and the far leg rests
on the ball of the foot. Thus animated,
the pose implies the notion of walking
and brings to mind Christ's post-
Crucifixion appearances, such as that
on the road to Emmaus.

In conceiving this bronze, Giulio
dal Moro at once followed and revised
an iconographic tradition common in
Venetian art and traceable from *The
Savior,* depicted in the background of
Carpaccio's *Vision of St. Augustine* in
San Giorgio degli Schiavoni, to statues
by Giulio's contemporaries, Danese
Cattaneo (Verona, Sant'Anastasia),
Alessandro Vittoria (Brescia, Museum),
and Girolamo Campagna (Venice, San
Moisè).

PC

Bibliography: Pollak, 1922, 117, no. 80,
xxxv; Santangelo, 1954, 44, fig. 47;
Comastri, 1988, 87-97

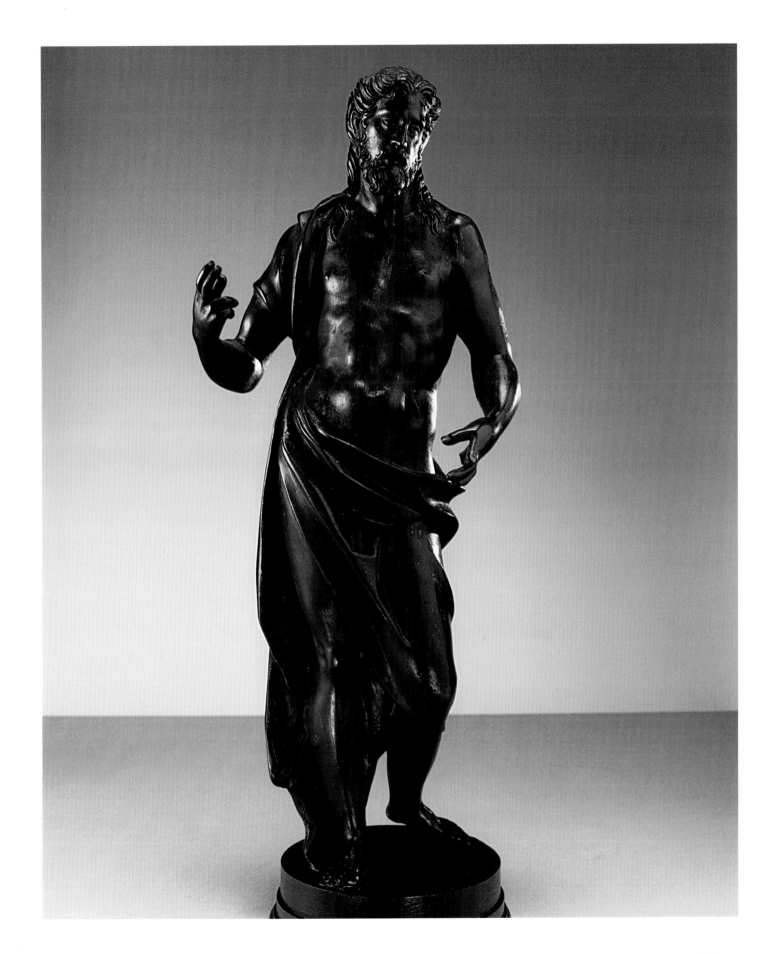

Giambologna
(Douai 1529-Florence 1608)

8

Peasant Leaning on a Staff,
1580-1600
Bronze with natural brown patina,
with reddish transparent spots
12.9 cm.
Inv. PV 10809
Provenance: Gift of Giacinto Auriti
1963, no. 40
Exhibitions: *Giambologna 1529-1608.
Sculptor to the Medici,* eds. C. Avery
and A. Radcliffe (Edinburgh, Royal
Scottish Museum, 1978, no. 137);
idem (London, Victoria and Albert
Museum, 1978); idem (Vienna, Kunst-
historisches, Museum 1978-1979)

The *Peasant Leaning on a Staff* forms part of a series of works that clearly reflect Giambologna's interest in genre subjects or character studies. In addition to this bronze the group also includes the *Seated Bagpiper* (Cat. No. 9), as well as other works, such as the *Duck-Girl* and various images of birdcatchers (see Cat. No. 10, a related work attributed to Romolo del Tadda). Similar images portray peasants, shepherds, and country folk in working dress. Such depictions were common in Flanders, Giambologna's home country, but in these statuettes the sculptor adapted his images in response to the demands of contemporary Florentine patronage.

One need only cite the example of Pratolino, a vast garden-park constructed by the architect Bernardo Buontalenti for Francesco I de' Medici. In addition to Pratolino's grottos, water effects, and both ancient and modern mythological or allegorical sculptures, its copious ornaments included "character" studies. The latter played a strong role in determining the appearance of Pratolino and were the first examples of a kind of embellishment that would continue through the late Baroque in other, equally famous gardens.

The garden at Pratolino was the first to evoke the many activities of country life by dispersing statues of peasants throughout the park. Surprise was the sought-after effect. First shown allegorical or wholly fantastical images, visitors were jolted back to earth by the sight of strikingly realistic figures wearing contemporary dress and engaged in the everyday labors of farming or village life. Although some modern interpretations have attempted to locate these figures within a classical *milieu*, such figures showed the dignity of those laboring far from the city and the court. According to the sixteenth-century writer Giorgio Vasari, such figures were invented by Baccio Bandinelli, and many of his drawings, which Vasari describes as being of a surprising realism, give proof to the assertion. It was, however, at Pratolino that such figures made their first appearance on a grand scale in works by Giambologna, Valerio Cioli, and their workshops.

Giambologna is known to have carved several statues of peasants, which are now lost. The *Peasant Leaning on a Staff* and the *Seated Bagpiper*, as well as the other related works cited in this entry date from the same period and may have served as models for his sculptures in stone.

PC

Bibliography: Planiscig, 1931, no. 40; Dhanens, 1956, 213; Santangelo, 1964, 28, XXXVII; Avery and Radcliffe, 1978, 165, no. 137; Avery, 1987, 47 and 266

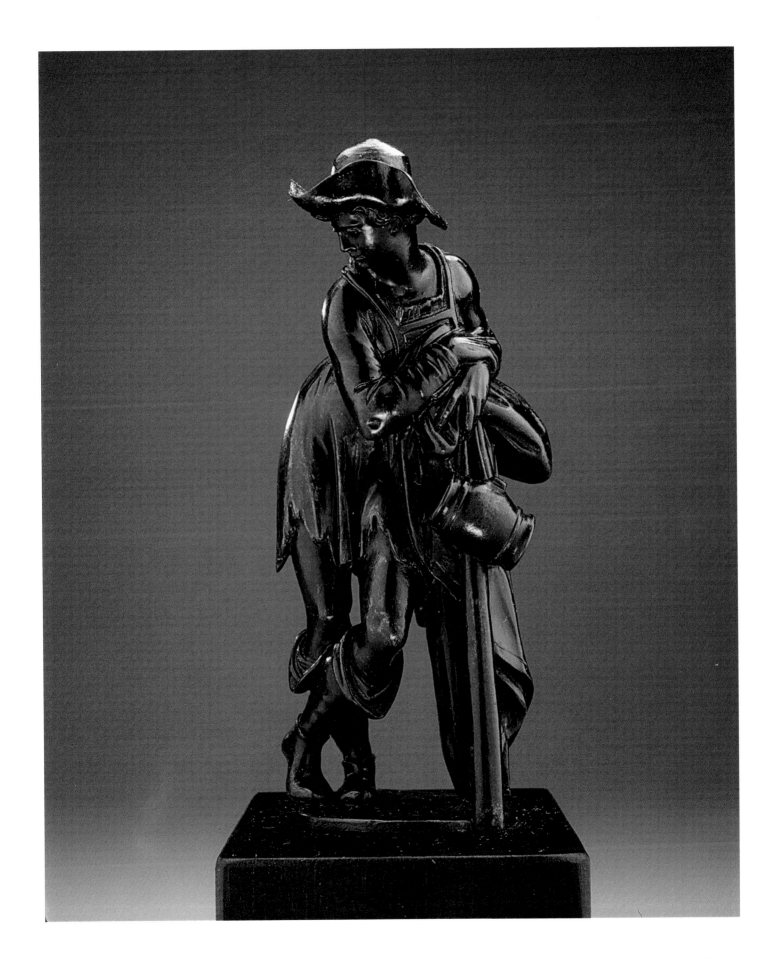

Giambologna
(Douai 1529-Florence 1608)

9

Seated Bagpiper, 1580-1600
Bronze with natural brown patina,
with reddish transparent spots
10.3 cm.
Inv. PV 10810
Provenance: Gift of Giacinto Auriti
1963, no. 41
Exhibitions: *Giambologna 1529-1608.*
Sculptor to the Medici, eds. C. Avery
and A. Radcliffe (Edinburgh, Royal
Scottish Museum, 1978, no. 136);
idem (London, Victoria and Albert
Museum, 1978); idem (Vienna, Kunst-
historisches, Museum 1978-1979)

Previous scholarship has already noted the similarity of the *Seated Bagpiper* to Dürer's 1514 engraving of a *Bagpiper* and has put forward the hypothesis that the small statuette, which was originally cast in silver, was intended to adorn an ebony cabinet (Avery and Radcliffe, 1978, 164 no. 136). As support for the latter notion, one may point to a finely chased gilded bronze from the Medici Collections and now in the Museo Nazionale del Bargello in Florence. Not only did the Medici bronze probably serve an analogous purpose, but it may also be regarded as Antonio Susini's translation of Giambologna's creation (Avery, 1987, 47).

Although freely executed, the *Seated Bagpiper* in the Palazzo Venezia was probably made by Giambologna himself. It was so catalogued by both Dhanens (1956, 213) and Santangelo (1964, 28) and was duly included in the exhibition held in Edinburgh, London, and Vienna. The original conception for this figure may be dated to the period between 1580-1600, when Giambologna was working on Francesco I's garden at Pratolino. A small version of the image is first documented in 1601, when four silver statuettes, then in the Uffizi, were lent to Antonio Susini for replication, possibly in bronze. Among them were depictions

"of a shepherd" and another described as "of a peasant with hat and rod leaning on his staff" (Avery and Radcliffe, 1978, 165, no. 137).

Pietro Tacca cast yet another example of "a shepherd who plays the bagpipe" as well as a "shepherd who is leaning on a staff, and has a keg" (see Cat. No. 8), three "small bronze figurines, about ¼ *braccia* high," and ten "bronze statues by Gio[vanni] Bologna varying in height between ½ to ⅔ *braccia*." These fifteen bronzes, made for Prince Henry of Wales, were copied from originals in the collection of the Marchioness Maria Maddalena Salviati at the Villa Gricciano (Watson and Avery, 1978, passim).

It should be noted that the earliest documents consistently pair the *Seated Bagpiper* with a *Peasant Leaning on a Staff*, but the two works appear together at last only in the collection of the Palazzo Venezia. Although the subject of a bagpiping figure is unusual in bronze, it recurs in another work in the Palazzo Venezia, a tiny and fragmentary seventeenth-century Flemish statuette.

PC

Bibliography: Planiscig, 1931, no. 41; Dhanens, 1956, 213; Santangelo, 1964, 28, XXXVIII; Avery and Radcliffe, 1978, 164, no. 136; Avery, 1987, 47 and 266

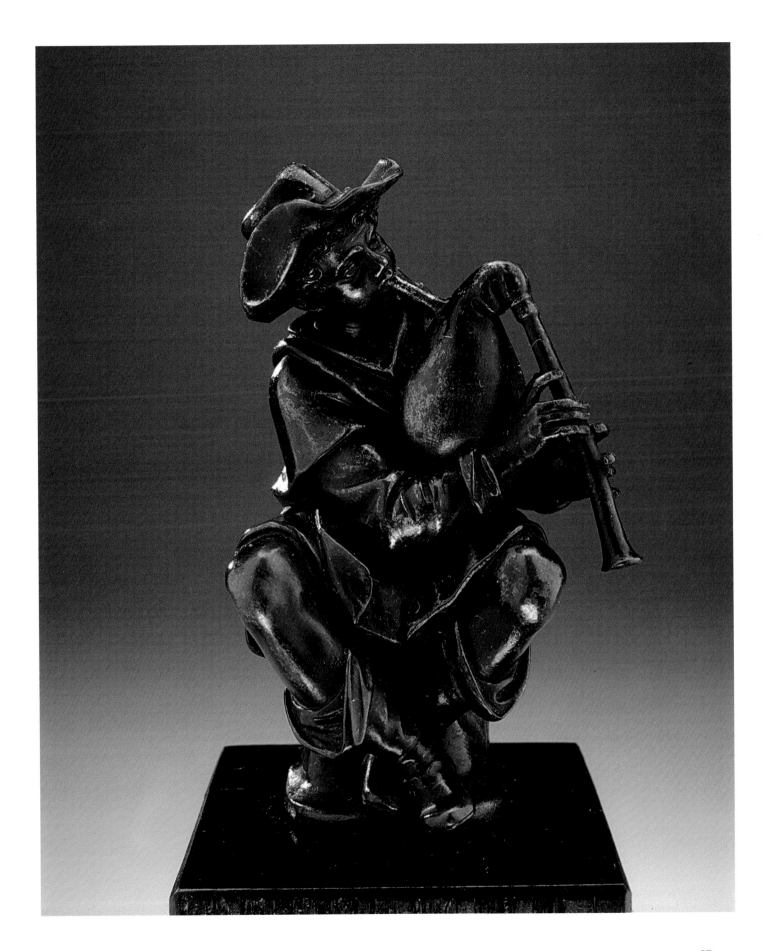

Attributed to
Romolo Ferrucci del Tadda

(Fiesole 1544-Florence 1621)

10

Birdcatcher, ca. 1600

Bronze with black lacquer, mostly lost

25.5 cm.

Inv. PV 9284

Provenance: Gift of Benito Mussolini 1934; *Cittadini e industrie milanesi* 1934; Alfredo Barsanti Collection, no. 57

Exhibitions: *Italian Bronze Statuettes* (London, Victoria and Albert Museum, 1961, no. 126); *Meesters van het brons der Italiaanse Renaissance* (Amsterdam, Rijksmuseum, 1961-1962, no. 124); *Bronzetti italiani del rinascimento* (Florence, Palazzo Strozzi, 1962, no. 122).

The chief feature of the *Birdcatcher* from the Palazzo Venezia is its sense of movement. Seemingly awkward, it in fact is so carefully controlled that it allows one to enjoy the sculpture from every angle. Leaning his body forward and turning his head to the side, the small figure walks on bended legs with only one foot solidly planted on the ground. Originally, the figure must have held a staff with a net in his right hand and, since birdcatching was done by night, a lantern in his left.

This somewhat boorish and grotesque figure recalls the work of Romolo del Tadda, in particular some of his garden sculptures in grey sandstone. The *Birdcatcher* may be compared with a *Caramogio* (literally "dwarf") in a Florentine private collection and especially with the three grotesque figures Tadda carved for the Boboli Gardens at the Pitti Palace in Florence. The latter, like the present work, sports caricaturish plebeian faces and display sharply disjointed movements, features that support the notion that they were based on drawings by Jacques Callot.

Although early sources say nothing about Tadda's ability to model and to cast, they describe him as an expert at cutting the hardest stones and marbles. Tadda produced two other sculptures for the Boboli Gardens. One depicted *The Game of 'Civetta'* (literally "owl" but analogous to tag) that was replaced by a copy in the eighteenth century. The second is a well-known stone group of the *Sacomozzone*, which was based on a composition by Orazio Mochi.

Noting the "brutal verism" of the face, Pollak (1922, 83) believed the *Birdcatcher* to be an early work by Giambologna and, in fact, a variation of his *Peasant Fowler*. Pollak noted that hunting birds with a "reflecting lantern" is also found in an image illustrating Giovanni Pietro Olina's rare 1622 volume on *Birdhunting*, which included engravings by Tempesta and Villamena.

In contrast to Pollak, Santangelo (1954, 54) attributed the *Birdcatcher* to Giovanni Caccini and noted that it differed in quality from Giambologna's sculptures. The *Birdcatcher* in the Palazzo Venezia is unknown in any other version. Nonetheless, Santangelo regarded it as one of the best examples of a well-known series of *Peasants* by such artists as Valerio and Giovanni di Simone Cioli, Orazio Mochi, and their late Flemish imitators. Santangelo also noted a connection between the present bronze and a bronze statuette of a *Peasant with a Small Barrel* (formerly in the A. S. Drey Collection, Munich), which was attributed to Romolo di Francesco Ferrucci del Tadda, and which the scholar believed had been based on models for a now-destroyed *Peasant Fountain* in Livorno. But for Santangelo the *Birdcatcher* was closest to the sculptures of Giovanni Caccini, above all his *Saint Alessio* from the church of Santa Trinita in Florence. Pollak's hypothesis is obviously indefensible, but so is Santangelo's. No proof exists that the bronze was copied from a model for the Livorno fountain, destroyed in the nineteenth century. It is equally impossible to support any connection between the *Birdcatcher* and the Drey *Peasant with a Small Barrel*, which Bode classified as a sixteenth-century North Italian work but which according to Draper is of indeterminate origin and cannot date before the eighteenth century (Bode, 1980, 108, CCVIII). Santangelo's attribution to Caccini, based in part on the unusual depiction of the latter's *Saint Alessio* in peasant dress, is also unpersuasive.

PC

Bibliography: Pollak, 1922, 83, no. 57, XXVI; Santangelo, 1954, 54, fig. 34

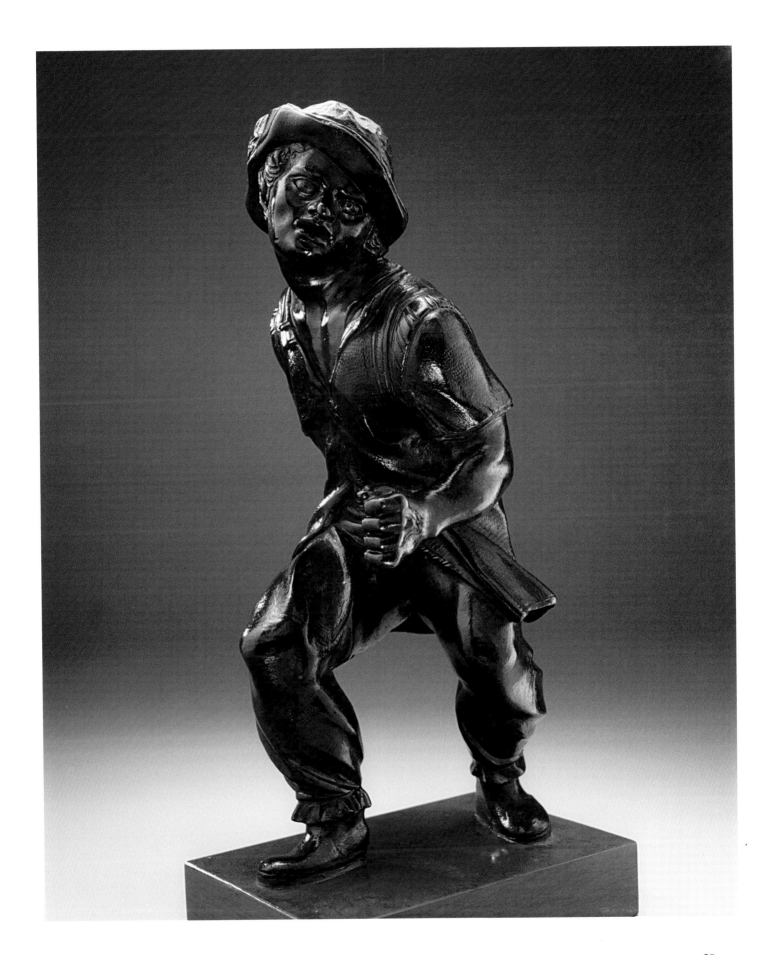

Antonio Susini

(Active in 1580-Florence 1624)

11

Crucifix, ca. 1609

Bronze and ebony

86 cm. overall; the figure of Christ

measures 39 x 31.2 cm.

Inv. PV 818

Provenance: Ministry of Public

Works, 1919

The *Crucifix* is attributable with certainty to Antonio Susini. As Giambologna's student and assistant after 1580, Susini copied and refined his master's models, while also producing designs of his own. He achieved a remarkable vitality in his sculptural works and a high degree of flawlessness in casting and finishing works in gold.

Susini's skill in modeling and casting works such as this *Crucifix*, no less than his popularity with noble patrons, is richly documented. Filippo Berardi, a clever agent for Duke Ferdinando Gonzaga of Mantua, wrote to his master in 1622: "*...il Susini ha fornito dieci Crocifissi, che cinque [sono] vivi e cinque morti. Ora V.S. comandi quelli che v[u]ole; et il prezzo è di dieci scudi l'uno....*" Berardi had hardly sent word before receiving the duke's immediate

and categorical reply: "*...pigliate i Cristi del Sussina et mandatemi il conto che vi si rimetteranno i danari*" (Luzio, 1913, 270-271). The document is of interest because it mentions that some of the crucifixes depicted Christ as dead, following a convention established in the thirteenth century, whereas others depicted Him as alive, following Counter-Reformation iconography initiated by Michelangelo.

The dimensions of Susini's crucifixes varied, as did the materials he used for the details. An inventory dated 1609 lists works of art, including a number of crucifixes, owned by the Marquess Lorenzo Salviati in his palace in the Via del Corso in Florence: one measuring "$\frac{1}{4}$ of a *braccio* [14.5 cm.] with an ebony cross, and in place of the hill [of Golgotha] there is a small sepulcher of ebony;" another measuring "$\frac{1}{2}$ of a *braccio* [29 cm.] with an ebony cross and a bronze hill [of Golgotha at the foot] and a base of ebony;" and yet a third measuring "$\frac{1}{2}$ of a *braccio* [29 cm.] high with an ebony cross and a ebony hill [of Golgotha at the foot] including a skull in bronze" (Watson and Avery, 1973, 493-507). Apart from the dimensions of the figure of Christ, Susini's crucifixes vary according to the way he depicted the mountain of Golgotha at the base of each cross. Sometimes cast in bronze and sometimes carved of ebony, it is also at times embellished with a bronze skull, the head of Adam, between crossed tibia.

The present example may be compared to another *Crucifix* by Susini in the collection of Smith College in Northampton, Massachusetts. Although both works show Christ as alive, the example at Smith is set on a bronze base. The workmanship of the cross and the scroll in the Smith version is finer than in the *Crucifix* from the Palazzo Venezia, but those features of the latter may not be original, because the Roman work is the better of the two versions in its beautiful definition of Christ's face.

It is impossible to determine if the *Crucifix* from the Palazzo Venezia is among those listed in the Salviati inventory, for Susini produced such works in great numbers. In his biography of Susini, Baldinucci (1846, IV, 109-118), who casts the sculptor as a saturnine and melancholy type, relates that the artist had a studio with two large chests, where he kept his finished works. When asked for a "Crucifix of such and such size, or another figure" (*un Crocifisso di tale, o tale grandezza, o altra figura*), he would simply select one from the chest, but if the proposed offer of money failed to satisfy him, he would wrap up the sculpture, put it back in the chest, and, without a word, sit on top of the box. Confronted with this tactic, an eager buyer might well have second thoughts.

PC

Bibliography: Cannata, 1988, 23

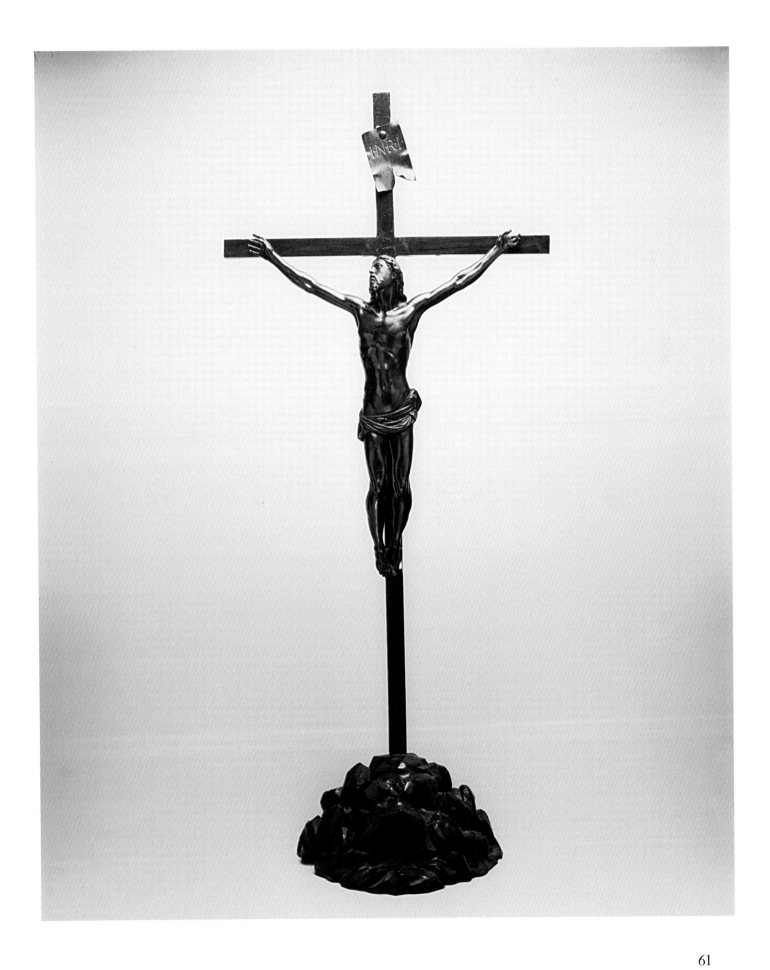

Hendrick de Keyser

(Utrecht 1565-Amsterdam 1621)

12

Putto, ca. 1615

Bronze with blackish-red lacquer,
mostly lost

13 cm.

Inv. PV9303

Provenance: Gift of Benito Mussolini
1934; *Cittadini e industrie milanesi*
1934; Alfredo Barsanti Collection,
no. 76.

The *Putto*, its face distorted in an expression of pain (not a smile, as suggested in the past), is here ascribed to Hendrick de Keyser, a famous Dutch sculptor and architect. This attribution depends on the similarities between the bronze in the Palazzo Venezia and other depictions of young children by the artist, whose faces are wracked by similarly strong emotions. With their exaggerated expressions that stop just at the limits of the grotesque or caricature, these images almost seem to anticipate the "physiognomic" busts of Franz Xavier Messerschmidt. Two small bronze busts, formerly in the collection of Cyril Humphris, London, and characterized by a lack of hair at the temples and bulging foreheads, have recently been restored to the artist's *oeuvre*. Their appearance may have been inspired by the head of the wind beneath Giambologna's *Mercury* from the Medici Collections (Museo Nazionale del Bargello, Florence), as well as by the depiction of the Christ Child in an *Adoration of the Magi* (Rijksmuseum, Amsterdam) painted by de Keyser's contemporary and countryman Hendrick ter Brugghen (Avery, 1973, 3-24; idem, 1981, 175-188). Although the bronze in Rome and the two in London have different dimensions, the relative size of the busts set on their rounded bases is similar.

Confirmation for the attribution of the Palazzo Venezia's *Putto* to de Keyser, made here for the first time, is furnished by a comparison with the marble bust of a *Crying Child* assigned to the same artist in the Statens Museum for Kunst in Copenhagen (inv. no. 5515; Harald Olsen, *Aeldre Udenlansk Skulptur*; Statens Museum for Kunst, Copenhagen, 1980, II, no. 155). The expressions on the faces are so close as to suggest that the two works were done at roughly the same time.

The date of ca. 1615 suggested for the bronze in the Palazzo Venezia is derived from a related work by de Keyser, the *Putto Carrying a Torch* that surmounts the famous marble and bronze tomb of William the Silent in the Nieuwe Kerk in Utrecht. The two *putti* share the same vexed expression, knitted eyebrows, wrinkled cheeks, open mouths, thickly modeled lips, dense curls, and recessed hairlines. This same ca. 1615 date was also recently proposed for another bust of a *Crying Child*, formerly in London and now in the Los Angeles County Museum of Art (Fusco and Schaefer, 1987, 142). The tonality of the patina and the luster of the bronze in the Palazzo Venezia *Putto* correspond to techniques commonly employed by the artist.

This small bronze was previously identified as a work by an unknown mid-sixteenth-century Italian artist by Pollak (1922, 112), who noted its resemblance to a plaquette. He also suggested that the motif of the broken, raised arm was intended to recall ancient sculpture. Pollak's mistaken attribution was upheld by Santangelo (1954, 38), who went on to suggest that the use of a Florentine blackish-red lacquer allowed one to assume that the bronze had been produced in Tuscany.

PC

Bibliography: Pollak, 1922, 112, no. 76, XXXIII; Santangelo, 1954, 38

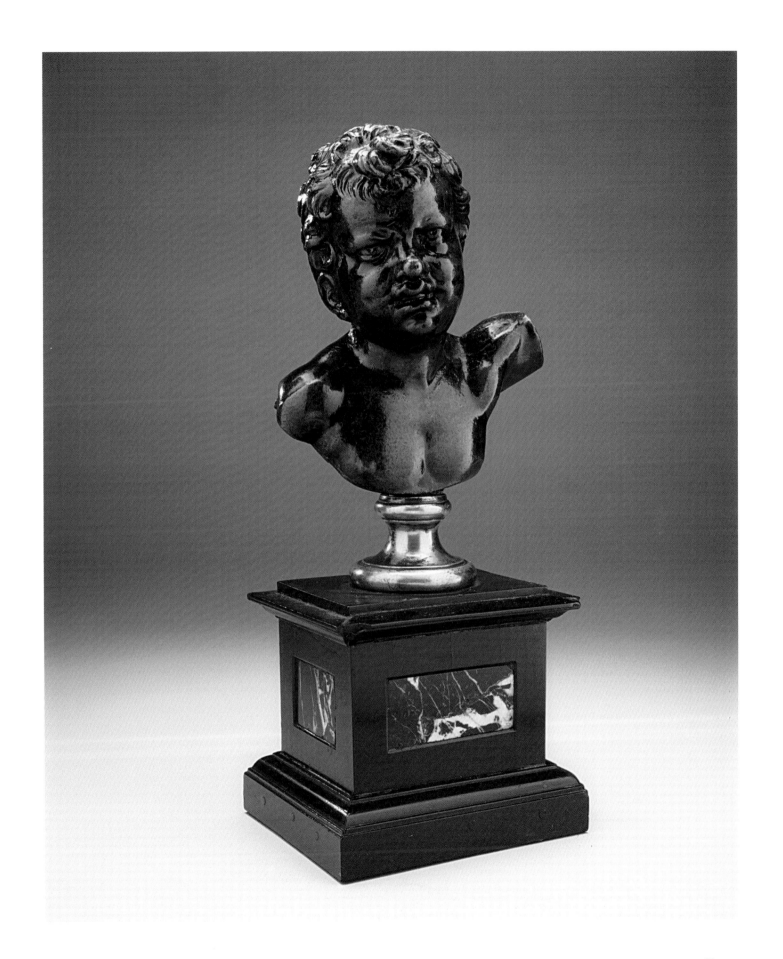

Alessandro Algardi

(Bologna 1598-Rome 1654)

13

Saints and Blessed of the Society of Jesus, 1629-1637

Gilded terracotta

29 x 51 cm.

Inv. PV 10395

Provenance: Cavaceppi Collection; Gorga Collection

This terracotta is a relatively early work by Algardi, a sculptor trained in Bologna by Giulio Cesare Conventi and Ludovico Carracci. The *bozzetto* is a study for the relief on a gilded bronze urn, executed by Algardi between 1629 and 1637. The urn, which preserves the remains of St. Ignatius of Loyola, rests beneath the altar dedicated to the saint in the Roman church of the Gesù. The attribution of this model to Algardi, made on the basis of style, has been confirmed by its relation to a preparatory drawing (Hermitage, St. Petersburg), also by Algardi (Montagu, 1985, I, 24-25).

The calculated linear clarity that characterizes the composition as a whole appears outmoded when compared to the spontaneity and brash style of that other great sculptor of the Roman Baroque, Gian Lorenzo Bernini. The fundamental difference between the works of these two sculptors arises from their distinct approaches to the study of the human figure. In Algardi's terracotta, the single figures, each with a small head and elongated body, enact their role in the collective history of the Jesuit Order via restrained gestures. Interest is focused, not on the individ-ual, but on a fluid movement from figure to figure, an equilibrium that ties the various parts of the composition together. For Bernini, on the other hand, each figure represents a separate, distinctive creation. During the same years that Algardi worked on this terracotta relief, Bernini executed a series of sketch models for the statue of *St. Longinus*, the great marble sculpture set up in the crossing of St. Peter's (1629-1638). Joachim von Sandrart, the German painter and historian who lived in Rome between 1629 and 1635, reported having seen more than twenty-two different *bozzetti* for the statue. Of these models, only two survive; one in the Museo di Roma, the other in the Fogg Art Museum at Harvard University (Lavin, 1978, 398-405). Even on such a reduced scale, one is impressed by Bernini's grandiose conception; the movement of the figure is powerfully portrayed, as is the expected interplay between light and form. Compared to such a personalized vision of the sculpted figure in space, Algardi's traditional composition even more clearly recalls his apprenticeship in the *Accademia* of the painter Ludovico Carracci.

In this terracotta Algardi attempts a depiction of a unique and complex theme, a ritualized commemoration by the Jesuit Order of the founders and early history of their institution. First among equals, St. Ignatius is exalted as the founder of the Society of Jesus and as the ideal representative of the Order's commitment to fight for the spiritual, political, and cultural glorification of the name of Jesus, not only in Rome, but throughout the world.

In the center of the relief is St. Ignatius who gazes upwards as he holds out the rules of the order. To his right stands Francesco Saverlo, a mem-ber of the Spanish nobility, who became a missionary in 1549, traveling first to India and then to Japan. Next to Saverlo is Roberto Bellarmine, who places his right hand on the head of St. Luigi Gonzaga, the son of Ferrante Gonzaga, lord of Mantua. Luigi Gonzaga was revered for his saintliness and for his dedication to the poor and to the sick. To St. Ignatius' left stands Francesco Borgia, the third general of the Order of the Society of Jesus. He holds out the monstrance (which contains the Eucharist) before which kneels the young Polish Jesuit, Stanislao Kostka. Just beyond, Ignatius of Azevedo displays a copy of the icon of the Virgin of Santa Maria Maggiore. In the back, three Jesuits with crosses commemorate the members of the Society martyred in Japan.

Unfortunately, some parts of the terracotta have broken off and been lost. A mediocre attempt to restore the *bozzetto* has further obliterated some details that are, however, visible in the final bronze version of the composition. By the eighteenth century, the model had entered the collection of the Roman sculptor and collector Bartolomeo Cavaceppi. Sold at the beginning of the twentieth century, it found its way first into the collection of Evan Gorga and then, in 1948, into the Palazzo Venezia, where it was attributed, wrongly, to Giuseppe Rusconi (Santangelo, 1954, 91).

MGB

Bibliography: Galassi Paluzzi, 1925, 17-18; Riccoboni, 1942, 177; Santangelo, 1954, 91; Heimbürger Ravalli, 1973, 130-131; Lavin, 1978, 398-405; Montagu, 1985, I, 24-25; II, 387-389; Levy, 1990, 212; Barberini, 1991, 33; Barberini and Gasparri, 1994, 133

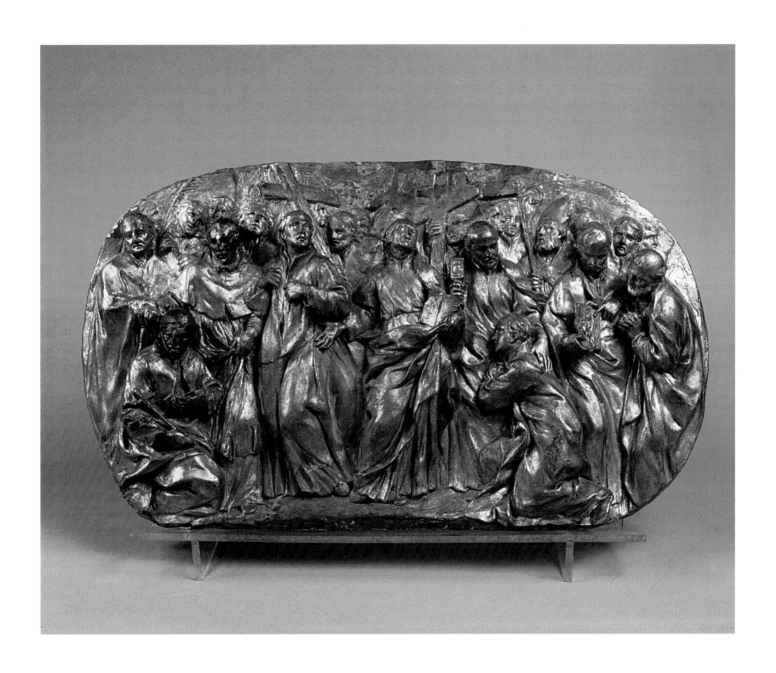

Alessandro Algardi

(Bologna 1598-Rome 1654)

14

Rest on the Flight into Egypt,

Ca. 1635-1640

Gilded bronze

31 x 38 cm.

Inv. PV 7963

Provenance: Gift of

Enrichetta Wurts 1933.

The high quality of this relief indicates that its author was Alessandro Algardi, the exact contemporary and rival of Bernini. Algardi employed all of his great technical skills in composing and in finishing this relief. The entire figure of the Christ Child, as well as the faces and hands of His mother and of Joseph, are more precisely chased than any other portion. Thus, the Child's body and the expressions and gestures of His companions stand out from the swirling mass of draped forms that covers the surface.

Typical of this sculptor's method, Algardi has simplified the representation of the *Rest on the Flight into Egypt* as much as possible. The landscape is limited to tufts of grass and a single tree in the background, while the four figures, giants in this small space, dominate the relief.

Both neo-Venetian classicism and mannerism are merged in this depiction of the *Rest on the Flight*. The influence of Ludovico Carracci, Algardi's teacher, is easily recognizable, as is Algardi's knowledge of other, near contemporary Bolognese painters such as Guido Reni. It is also appropriate in this context to mention Simone Cantarini. By his constant reiteration, *ad infinitum*, of the same subject in his paintings and etchings, Cantarini succeeded in creating an iconographic canon for such scenes. Ultimately, he even influenced the choice of themes represented by other artists.

Numerous examples of this relief exist in both oval and octagonal format. Some are cast in bronze, other casts were gilded, still others made of lead, silver-plated copper, and even gilded copper. Montagu lists fourteen examples in her 1985 monograph on Algardi, but other versions continue to appear in sale catalogues. Often there are variations in composition as well as in material. Some of the reliefs are reduced in scale, in others the angel or some other detail is omitted, further simplifying the composition. There are also variations in technique; some versions are notably cruder than others, lacking the refinement of surface that exemplifies Algardi's autograph production. Testifying to the extraordinary popularity of this depiction of the *Rest on the Flight into Egypt* are two more examples, one in terracotta, the other in painted copper. In addition to the well-known marble reproduction of the relief in the Palazzo Pallavicini Rospigliosi (Rome), on the occasion of this exhibition in Athens, another marble variant can be cited for the first time. Of fine quality, this latter relief is found in the antechamber of the chapel in the Villa Malta, Rome.

PC

Bibliography: Cannata, 1982, 76-77, no. 76; Montagu, 1985, II, 308, no. 4.C.II

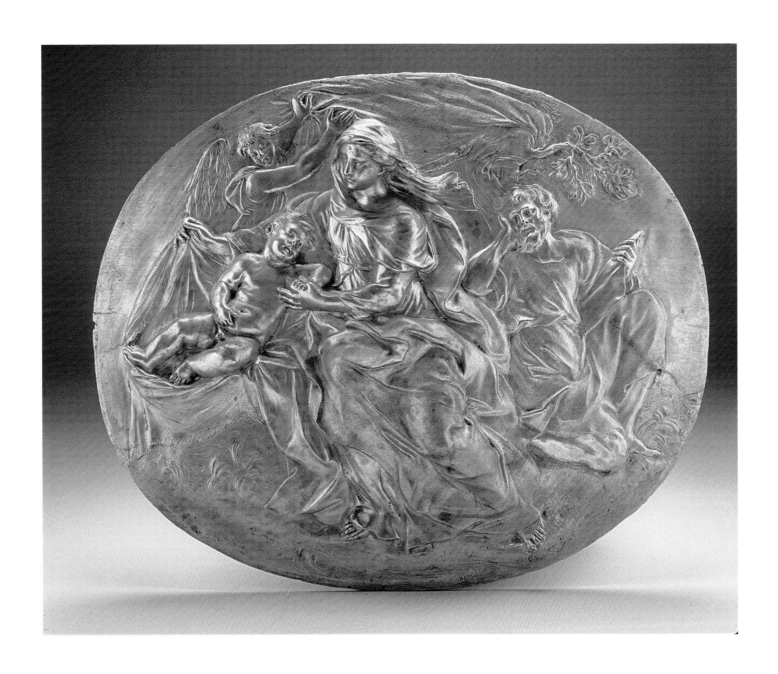

Gian Lorenzo Bernini

(Naples 1598-Rome 1680)

15

Angel with the Superscription,
1668-1669

Red terracotta

36 cm.

Inv. PV 1195

Provenance: Cavaceppi collection;
Ferroni Collection; Gorga Collection.

This terracotta *bozzetto* is Bernini's first study for the marble *Angel with the Superscription* (1668-1669), which stands today to the right of the altar in the church of Sant'Andrea delle Fratte, Rome. Its pair is the marble *Angel with the Crown of Thorns,* installed on the left side of the high altar in the same church. Both sculptures were, however, originally intended for another location. In 1667, several months after his ascension to the papal throne, Clement IX Rospigliosi (1667-1669), decided to embellish the Ponte Sant'Angelo, the most important of the bridges linking the old city of Rome with the newly revitalized region around the Vatican. The original bridge, known as the Ponte Elio, was built at the same time as Hadrian's mausoleum and allowed passage from the ancient city to the imperial tomb. Later decorations added to the bridge, first winged *Victories* and then statues of patriachs and evangelists, were replaced by ten angels designed by Bernini. Each angel carries a different instrument of Christ's Passion. These fervent angels accompany pilgrims as they cross the Tiber, on their way to

the sacred shrine built over Peter's tomb, the rebuilt basilica of St. Peter's.

Participating in this project were the most important sculptors active in Rome. Twelve sculptures were actually completed in marble: the ten angels still *in situ* on the bridge and the two angels now in the church of Sant'Andrea delle Fratte, finished by Bernini himself in 1669.

Writing in 1681, Baldinucci reports that Clement IX was so impressed by the beauty of these two angels, that he refused to allow the statues to be placed on the bridge, where they would be exposed to the elements. Instead, two variants were carved for the Ponte Sant'Angelo and the pope's cardinal-nephew was charged with finding a more appropriate site for Bernini's angels. But the great master's two sculptures remained in his studio until 1729 when Prospero Bernini, the sculptor's nephew, gave them to the church of Sant'Andrea delle Fratte.

The clay *bozzetto* in the Palazzo Venezia is an initial trial piece. Its early place in the genesis of the statue is evident in the model's comparative lack of emotional intensity and in the drapery. The compressed folds gradually dissolve into unarticulated waves of movement. Equally significant variations can be noted in the garment still covering the angel's shoulders and arms and in the relatively two-dimensional conception of the figure as a whole. This early *bozzetto* is designed with a single frontal view rather than in the round. But its intended location on the bridge is clearly suggested by the perspective. The angel is best viewed from below, as if it were already standing on the balustrade of the Ponte Sant'Angelo.

Critics have always considered this model to be the first study for the *Angel with the Superscription*, produced

together with another *bozzetto* (Fogg Art Museum, Harvard University) for the *Angel with the Crown of Thorns*. In both these early studies the angels hold their respective symbols over their freestanding legs, but in later studies, this symmetry disappears. It is, therefore, possible to suggest a sequence for the entire series of *bozzetti* and drawings associated with these two sculptures. The first studies are represented by a quick sketch for the *Angel with the Crown of Thorns* (Museum der Bildenden Künste, Leipzig), followed by the *bozzetto* for the same statue in the Fogg. From this same period comes the model in the Palazzo Venezia. A second phase in the design, which is obviously closer to the final form given to the angels, is recorded in a drawing for the *Angel with the Superscription* (Gabinetto Nazionale delle Stampe, Rome), and a series of *bozzetti* for the *Angel with the Crown of Thorns* in the Louvre (Paris), the Davis Collection (London), and the Fogg Art Museum. Together with the Hermitage (St. Petersburg), the Fogg also possesses successive studies for the *Angel with the Superscription*. Through these examples, one can trace Bernini's refinement of a single composition: he began with a drawing then moved to three-dimensional studies in clay. These successive stages allowed Bernini to maintain a vibrant immediacy, while avoiding any traces of academic formality.

To appreciate Bernini's working method one must understand his ingenious means of preserving the creative process itself. Bernini's contemporary, Joachim von Sandrart, writes that the sculptor always produced a variety of studies before confronting the block of marble. In each, the ideation of the pose is considered anew; visible knife slashes and fingerprints on the surface embody the dramatic tension inherent

in this seemingly endless labor of revision and modification. Once past a certain point, however, each model was put aside as an object of little importance. This is presumably what happened to the *bozzetto* in the Palazzo Venezia. Fortunately the model was preserved, perhaps by Bernini's assistant Guilio Cartari. From his collection, it passed into other studio collections, until it, along with other studies by Bernini, came into the possession of Bartolomeo Cavaceppi. After Cavaceppi's death in 1799, his *bozzetti* were acquired by the Duke of Torlonia. On the art market again at the beginning of this century, they were bought by Gorga and Piancastelli, eventually finding their way into the museum at the Palazzo Venezia.

MGB

Bibliography: *Bollettino d'Arte,* 1909, 279; Mariani, 1929, 59-65, n. 11; *Roma seicentesca* (exh. cat.), 1930, no. 795; Riccoboni, 1942, 164; Grassi, 1946, 186-199; Hermanin, 1948, 278; Santangelo, 1954, 78; Grassi, 1962, 133; Wittkower, 1966, 248-251; Lavin, 1968, 233-248; Fagiolo Dell'Arco, 1969, 220; Weil, 1969, 81; idem, 1971, 252-259; Wittkower, 1973, 203; idem, 1977, 236-241; Lavin, 1978, 398-405; D'Onofrio, 1981, 81; Lavin, 1981, 288-292; Mezzatesta, 1982, cat. nos. 8-9; Pope-Hennessy, 1986, 439; Avery, 1988, 12, 31; Barberini, 1991, 47-48; Barberini and Gasparri, 1994, 119-125

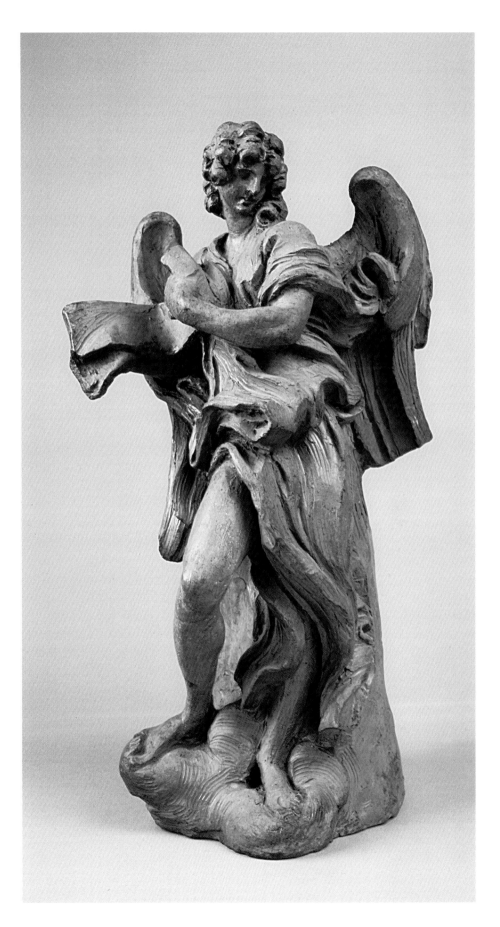

Gian Lorenzo Bernini

(Naples 1598-Rome 1680)

16

Portrait of Clement X, ca. 1670

Bronze

Diameter 27.8 cm.

Inv. PV 1637

Provenance: Collection of a Roman prince (Castel Sant'Angelo, 1920)

Exhibitions: *Roma secentesca* (Rome, 1930, no. 35); *L'Arte degli Anni Santi-Roma 1300-1875* (Rome, Palazzo Venezia, 1984-1985, no. X.28)

Seven popes, Paul V Borghese, Gregory XV Ludovisi, Urban VIII Barberini, Innocent X Pamphili, Alexander VII Chigi, Clement X Altieri, and Innocent X Odeschalchi, all called on the services of the great Roman sculptor Bernini. Although their commissions for monumental sculptures are perhaps more famous today, during the almost seventy years of his artistic career Bernini also made at least one, and sometimes more, portraits of each of these popes. The significance of these portraits is two-fold: they represent major innovations in the iconography of papal portraiture as well as epitomizing some of the highest technical creations of the period. While some of Bernini's portraits are idealized, courtly depictions, others courageously reveal, and even celebrate, the sitter's true character.

During the pontificate of Clement X (1670-1676) Bernini worked on several different portraits of the pope. According to one manuscript source the pope commissioned three busts from Bernini. This record, dated May 5, 1676, is found in the memoirs of the well-placed and erudite Carlo Cartari, the cousin of Bernini's pupil Giulio Cartari and the consistorial lawyer as well as archivist at the Castel Sant'Angelo, who also served as the librarian for the pope's nephew, Cardinal Paluzzo Altieri. The three papal portraits were each intended for different locations: the refectory of SS. Trinità de' Convalescenti, the cardinal's own chamber, and the library of the grand Altieri palace at the Gesù. The histories of these three busts are fully delineated in the most recent edition of Wittkower's monograph on the sculptor (1990, 298-299).

Again according to Cartari, Bernini also made a medallion portrait of the pope. This reference comes from a different manuscript, a list compiled by Cartari of the medals owned by the Cardinal Massimo, which was completed on October 24, 1677. The medallion portrait of the pope is described as: "*Effige di Clemente decimo assai bella, del Cavaliere Bernino; senza lettere e senza rovescio*" ["A rather beautiful image of Clement X by the Knight Bernini; without an inscription or an image on the reverse"]. Undoubtedly, the medallion described by Cartari is the bronze now in the Palazzo Venezia.

This medallion depicts the pope in profile. It is a truly remarkable work, especially notable because of the refined details of its finish. The sculptor's extraordinary technical prowess can be seen with particular clarity in the skillful manipulation of the surface. The hair and ears are distinguished by miniscule punchmarks; the background is granulated; the collar is differentiated by small, even hatching; the highly polished garments and headpiece look like satin; and it is light passing over the surface, not the presence of small, incised details, that modulates the plastic structure of the face itself.

Although the attribution of the Palazzo Venezia medallion to Bernini was rejected by Martinelli, it has been supported by Bimm (1971, 72-76), Balbi De Caro (1974, 16-21), and the author of this entry (Cannata, 1984, 428-429). Its relation to an important red chalk drawing, a profile portrait of the pope but facing in the opposite direction from the medallion, now in the Museum der Bildenden Künste in Leipzig, has been noted on several occasions. The same date of ca. 1670 has been proposed for both works. Between the drawing and the bronze, there are, however, differences in the depiction of the facial features and, even more significant, in the positioning of the head and shoulders which alters the characterization of the pope. The medallion extols the powerful and vigorous elderly pope, whereas the drawing depicts a resigned old man in his declining years. It is, therefore, likely that the two depictions were done at different times, the medallion during the first years of Clement X's pontificate, the drawing during the last years.

Other versions of this relief have been noted in a private collection and formerly in the Heim Gallery, London. The Metropolitan Museum of Art in New York owns another that was recently attributed to Girolamo Lucenti. This relief, an enlarged and simplified reworking of Bernini's portrait, includes an inscription identifying the sitter as "CLEMENT X . P . O . M ."

PC

Bibliography: Piacentini, 1940, 77, III; Martinelli, 1955, 666, n. 1; Martinelli, 1956, 52-53, n. 1; Bimm, 1971, 72-76; Balbi de Caro, 1974, 16-32; Cannata, 1984, 428-429, no. X.28

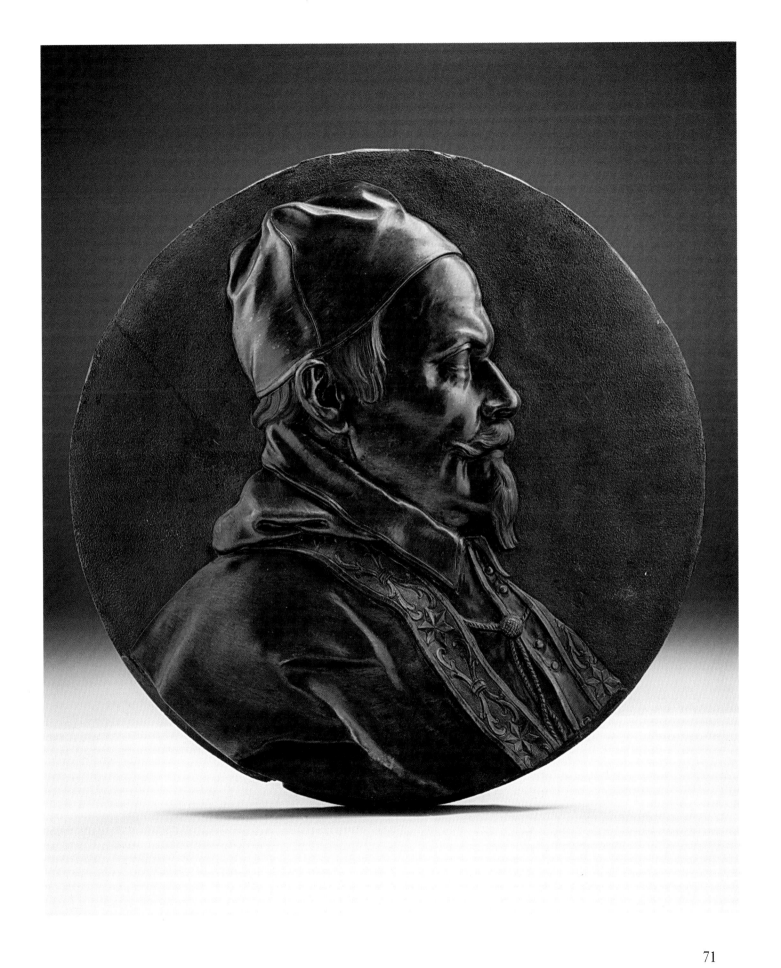

Melchiorre Caffà

(Vittoriosa, Malta 1638-Rome 1667)

17

St. Rosa of Lima, 1665

Reddish terracotta

14.7 cm.

Inv. PV 1210

Exhibitions: *Mostra d'Arte retrospettiva* (Rome, 1911)

In 1564 the Council of Lima met to reiterate the need to convert the indigenous populations of Latin America. Following a recommendation recently proposed at the Council of Trent, it was suggested that all of the mysteries of the Christian faith should be presented in images so that the local population could be made more aware of the miracles performed by God through the agency of his saints (Araoz-Ramon, 1995, 137).

More than twenty years later, in 1586, the future St. Rosa was born in Lima, Peru. She devoted her life to an unending series of ascetic mortifications. Rosa joined the Dominican Order and died in 1617. Between 1636 and 1639 the Congregation of the Propaganda Fide sent a steady stream of Augustinians, Mercedarians, and Jesuits as missionaries and apostolic preachers to Peru (Pastor, XIII, 787-790). During these same years, members of the Mercedarian Order wrote to Pope Urban VIII Barberini: "The Queen of Flowers is needed for the City of Kings [Ciudad de los Rejes, i.e. Lima]. By writing on this Rosa the name of the city of Kings we shall finally be able to answer the enigma of Menalca found in Virgil's Third Eclogue: 'Tell me where is the region where flowers are born with the words "de los Rejes" written on them?' With such flowers surely we can expect the fruits of honor and the riches of virtue?" (Araoz-Ramon, 1995, 157).

The Dominican Order, to which Rosa had belonged, was particularly active in glorifying the memory and circulating the image of their Peruvian sister. In 1663 the Dominicans commissioned a statue of Rosa from Melchiorre Caffà. Within a year, the unfinished statue had already become famous. Completed in 1665, as recorded in the inscription's base: *Melchor Caffà-maltensis-Roma A de 1665, f.e.d.*, the sculpture was displayed to the public in the basilica of Santa Maria sopra Minerva on May 12, 1668. For the occasion, a temporary backdrop was set up in the form of a half moon, ornamented with pedestals and painted columns. On each column appeared the image of a saint who was connected in some way with Rosa. Caffà's marble statue was placed in the middle of the altar. The climax of the conceit appeared above the sculpture, where an image of the Virgin holding the Christ Child entreated a small angel, an emblem of Divine Love, to awaken the young Rosa from her mortal sleep. After the intercession of Pope Clement IX Rospigliosi the statue was sent to the Order of Preachers in Lima so that it could be installed in the chapel of the royal palace. Later it was moved to San Domenico. Only in 1670 did the sculpture reach its final destination in Callao where, upon its arrival, it was met with a triumphal procession. It should be remembered, however, that it was only in the following year, 1671, that Rosa was canonized by Clement X Altieri. The first American saint, she was proclaimed patroness of the Americas and the Indies.

The terracotta now in the Palazzo Venezia was only identified in 1969 as the earliest preparatory study by Caffà for this sculpture (Preimesberger, 1969, 178-183). Before this discovery, the model had been attributed to Bernini and associated with his studies for the figure of the *Blessed Ludovica Albertoni* in the church of San Francesco a Ripa, Rome (Santangelo, 1954). It is worth noting that Bernini's sculpture is dated to 1671, at least eight years after Caffà began working on his sculpture of *St. Rosa of Lima*.

The subject, easy to discern in the study, depicts the dead saint. That this is the theme of the work, not the ecstatic visionary experience depicted by Bernini, is specified in the title of a short sonnet written on the occasion of its display at the Minerva: "*Per la statua in marmo della Beata Rosa di Lima, addornamenta e destata da un angelo, prima della beatificazione*" [For the marble statue of the Blessed Rosa of Lima, asleep and awakened by an angel, before her beatification] (Araoz-Ramon, 1995, 156).

The beatified Rosa is depicted on a high, rocky knoll abloom with roses. The legs of the angel can just barely be discerned. The complete relaxation of Rosa's body is magnified by the elongated, flat folds of her garment. Caffà, a generation younger than Bernini, seems perfectly aware of the master's example: undoubtedly, the iconography refers to Bernini's *Ecstasy of St. Teresa* of 1652 in the church of Santa Maria della Vittoria. But it is clear that the younger sculptor's underlying intentions are different. Teresa, wounded by Divine Love, is in a profound visionary state. The complex theological meaning of Bernini's *St. Teresa* has been perfectly explained by Lavin (1980, passim). Rosa, on the other hand, is being

reawakened from the sleep of death into a new life, illustrating St. Paul's thinkings about the hope of resurrection into immortal life.

Other depictions of the dead St. Rosa occur in contemporary bronze statuettes (examples are recorded in the Faldi Collection and the Heim Gallery, London). In such examples, the figure is further elongated and she is shown with a pillow beneath her head as if in bed (Nava Cellini, 1956, 114 n. 16).

MGB

Bibliography: *Mostra d'Arte retrospettiv* 1911, 86; Hermanin, 1948, 278; Santangelo, 1954, 91; Nava Cellini, 1956, 21; Preimesberger, 1969, 178-183; idem, 1973, 16; Lavin, 1980, 71-75; Di Gioia, 1987, 39-53; Barberini, 1991, 46; Araoz-Ramon, 1995, 153

Ercole Ferrata

(Pellio Inferiore, Como 1610-
Rome 1686)

18

Triton for a Fountain, ca. 1670

Reddish-grey terracotta

39 cm.

Inv. PV 4258

rior to its restoration in 1970, the *Triton* held up a shell in his left hand. This detail, and indeed the entire left arm, had been added during an earlier refurbishing. Especially with the shell, the allusion to Bernini's 1642-1643 *Fountain of the Triton* was unmistakable. In Bernini's work, the marine demigod kneels on an open shell held up on the tails of four dolphins; he blows into his conch shell, causing a stream of water to jet upward into the air before cascading into the surrounding basin. Because of the resemblance between the reconstructed *Triton* and Bernini's fountain, Santangelo (1954, 80) attributed the Palazzo Venezia terracotta to Bernini, even though he was unable to determine the work for which the model was made. But this generic reference to the compositions of Bernini cannot hide the decidedly summary quality of the execution. This is especially evident on the back of the figure, where the tail is unmodeled and the right arm and hand are rather shapeless.

In a forthcoming publication that includes important documentation, Jennifer Montagu suggests that the terracotta is a model for one of the four tritons on the *Fountain of Neptune,* now in Queluz, Portugal, but originally planned for the garden of the palace of Anunciada. This fountain had been commissioned by Luis de Meneses, the third count of Erceira in ca. 1670. In addition to the documents from Portugal, Montagu also quotes from Baldinucci's life of Ferrata, where the author mentions that "for Portugal he [Ferrata] created a Neptune with four tritons, with several dolphins and other fish, to be used as a fountain; the Neptune is ten palms in height."

The Lombard sculptor Ercole Ferrata continues to be an unfamiliar artist even to many scholars. We still know little about his career. Among the tantalizing bits of information that have come to light is the fact that he was Alessandro Algardi's heir, receiving at the latter's death Algardi's entire collection of studies and models. Ferrata ran a busy workshop in Rome, where a generation of sculptors trained. It was in his studio that the fusion of Bernini's and Algardi's styles, which characterizes the artistic direction of the second half of the seventeenth century, took place. It is, therefore, not surprising that for this *Triton* Ferrata drew on ideas culled from works produced decades earlier by Bernini.

MGB

Bibliography: Santangelo, 1954, 80

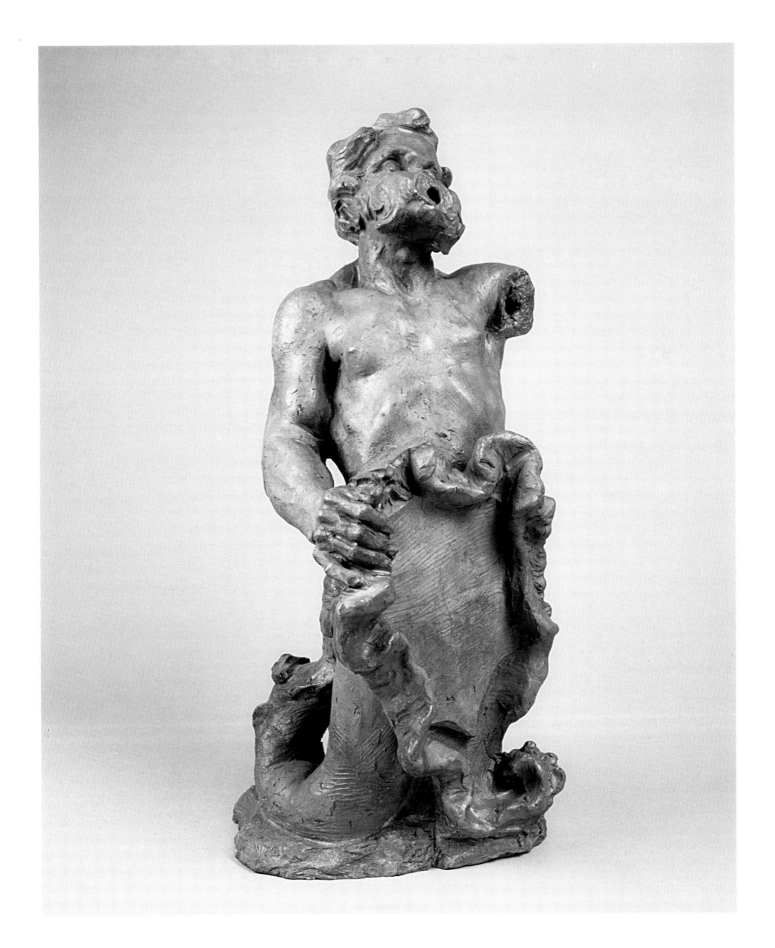

Pietro Paolo Naldini
(Rome 1619-Rome 1691)

19

Angel Supporting a Console,
1673

Reddish-grey terracotta

28.5 x 21.5 cm.

Inv. PV 1201

Exhibitions: *Mostra d'Arte retrospettiva* (Rome, 1911)

This terracotta model is a study for the support beneath the pulpit, completed in marble in 1673, that faces into the nave of the church of San Marcello al Corso, Rome. The splendid invention of this activated angel exemplifies the sensual humanity of high Baroque sculpture. The angel, an apparition from heaven seated on a starry globe, acts as a caryatid who holds aloft the structure of the pulpit. The concept, in which the angel both seems to be hovering weightless in space and supporting the earthly gravity of the pulpit, reflects the influence of Bernini's boundless imagination. Bernini peopled the churches of Rome with an endless array of such genderless, supernatural figures. Naldini worked for Bernini at Santa Maria del Popolo and on the *Cathedra Petri* in St. Peter's where two similar angels, in pseudo-heraldic poses, appear to either side of the throne.

We also know that while working in Bernini's studio, Naldini copied his master's *Angel with the Crown of Thorns*. The original marble statue carved by Bernini, along with its companion *Angel with the Superscription* (Cat. No. 15), was deemed too fine to be placed on the bridge and both were installed, eventually, in Sant'Andrea delle Fratte. It is Naldini's copy that stands on the Ponte Sant'Angelo. For his own use, Naldini also made a copy of another one of the Ponte Sant'Angelo angels, the *Angel Holding the Dice and Christ's Robe.*

Naldini's initial training in the studio of the painter Andrea Sacchi is also evident in this work. The vigorous modeling that reveals a strong strain of classicism depends, at least in part, on this early influence.

MGB

Bibliography: Hermanin, 1948, 280; Santangelo, 1954, 90, fig. 101; Martinelli, 1956, 359; Gigli, 1977, 62-63; Barberini, 1991, 53

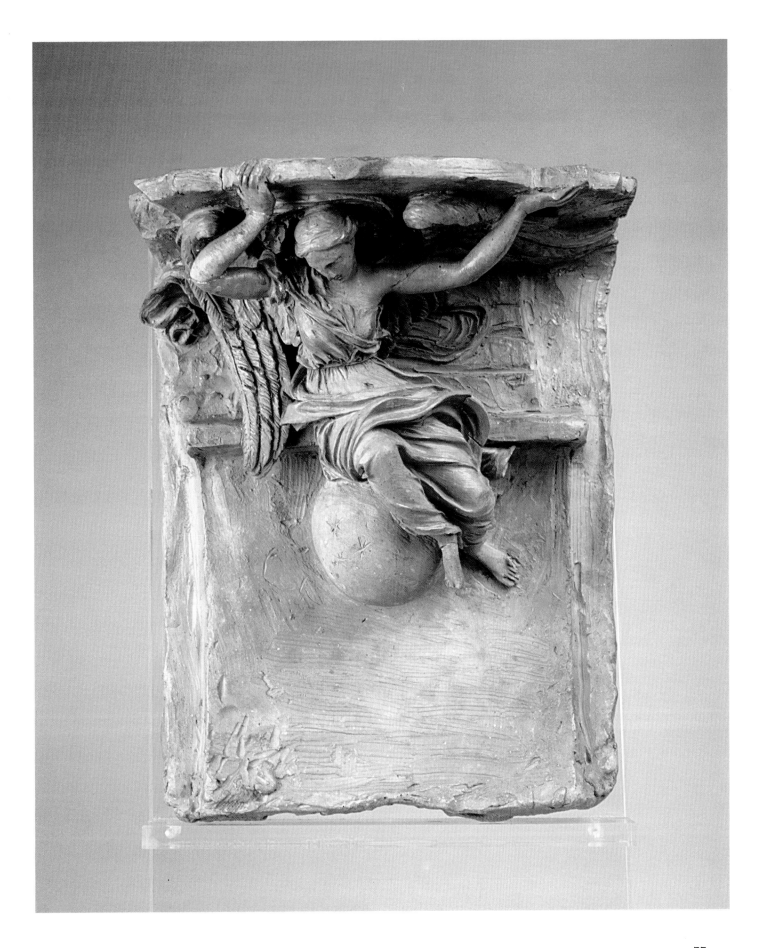

Unknown

Flemish Artist (formerly attributed to Gabriel Grupello)

20

Écorché,

Late 17th-early 18th century

Bronze with clear brown natural patina, with remains of black lacquer

43.5 cm.

Inv. PV 10822

Provenance: Gift of Giacinto Auriti 1963, no. 53

This small bronze is an anatomical study. Such objects, frequently found in workshops, studios, and academies of art, were used by artists and their students to learn anatomy. Although this example is in bronze, more often the studies were in plaster, and there are even some surviving examples in wax.

There are numerous drawings and engravings that show artists and their students hard at work reproducing such models. Among the most interesting for the present discussion, because it was produced at approximately the same time as the Palazzo Venezia bronze, is a drawing done between 1677 and 1683 by Carlo Maratta and then engraved by Nicolas Dorigny, who included a long, descriptive inscription at the bottom of the engraving (*L'Accademia del Disegno*, engraving, ca.

1700, Istituto Nazionale per la Grafica, Rome, no. 23607). The drawing and the engraving show numerous students working in a studio. Some are observing and copying ancient statues while others study a large anatomical figure set on a high base. Leonardo da Vinci is depicted turning toward the anatomical figure and explaining to two students, as one reads in the caption: "This is what is necessary [to teach] the correct proportions of the limbs, and location of the muscles, and nerves, which make up the figure." It is especially interesting to note how similar, particularly in the placement of the head, legs, and arms, are the anatomical figures in Maratta's composition and the bronze statuette from the Palazzo Venezia.

Planiscig (1931, no. 53) identified the artist who made this small bronze as a seventeenth-century Florentine. By contrast, Santangelo (1964, 33) was convinced that, due to its resemblance to a bronze statue of the *Flayed St. Bartholomew* in Munich (see Zuraw, note 29), the bronze statuette was a work by Gabriel Grupello (1644-1730). Unfortunately, neither attribution is fully convincing because of notable differences in composition and technique. Even though the sculptor remains anonymous at this point, he can be identified as a Flemish artist of the seventeenth or early eighteenth century.

This Flemish master was clearly an artist of considerable gifts. The harmony of the composition and the elegance of the execution transcend the limitations of its "function" as a model in the studio. Rather than a single viewpoint, the statuette is designed to present an endless variety of different views. Indeed, it might be argued that the views from the side, traditionally conceived of as secondary, are more interesting than that from the front. The continuous modulation of the surface forms, most notably the muscles, lends a highly expressive quality to this bronze, both as object and as subject. An interior centrifugal force spins the figure in a vertical helix. This dynamic pose is counterbalanced by the support behind the figure.

The bronze from the Palazzo Venezia forms part of a long and important tradition of flayed men, or *écorché* figures. The first, in a mannerist style, were done in bronze by Pierre Franqueville (two different examples are to be found in the Muzeum Universytetu Jagiellonskiego, Cracow). Another example is in wax, the work of Andrea Commodi (Victoria and Albert Museum, London). The most famous of these figures is that produced by Ludovico Cardi, known as Cigoli. His *Flayed Man* was modeled in wax and only cast in bronze after 1678 (Museo Nazionale del Bargello, Florence).

A copy in lead of the Palazzo Venezia figure was once in the now-dispersed collection of Camillo Castiglioni, Vienna.

PC

Bibliography: Planiscig, 1931, no. 53; Santangelo, 1964, 33, XLIX

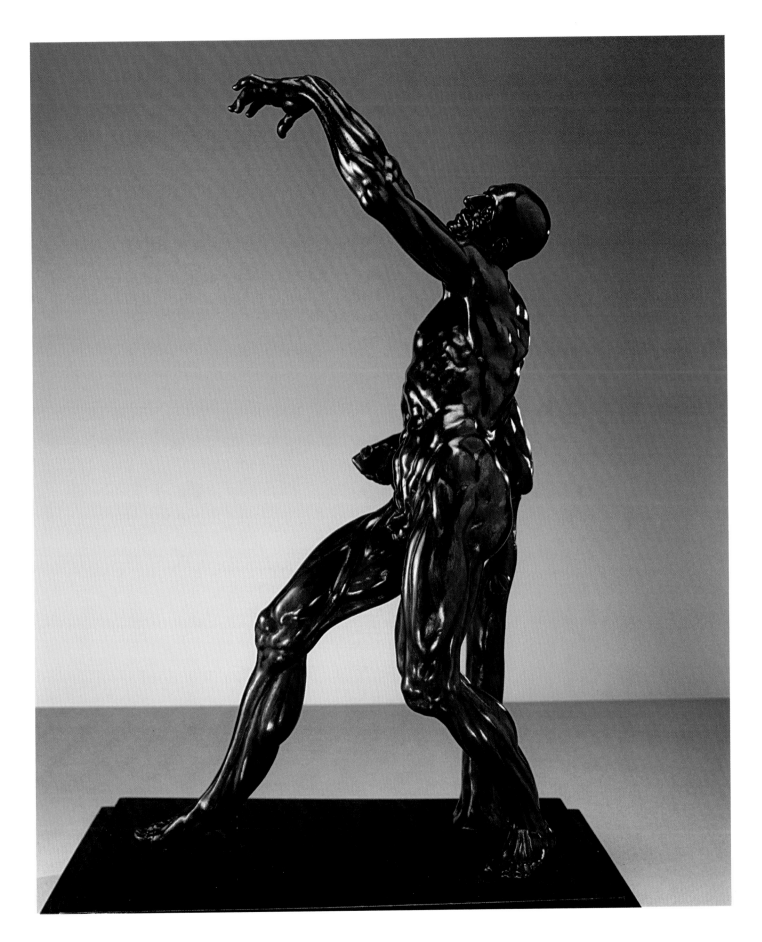

Giuseppe Mazzuoli

(Siena 1644-Rome 1725)

21 and 22

Annunciatory Angel
and *Virgin Mary*, ca. 1694

White marble

Each, 51 x 38.5 cm.

Inv. 42411-42412

Provenance: Art market

The two oval-shaped, marble reliefs, inserted into rich wooden frames carved during the same period as the reliefs, are the work of Giuseppe Mazzuoli. A Sienese sculptor, Mazzuoli worked for many years in Rome and his style clearly reveals the influence of Bernini. Mazzouli represents a younger generation of sculptors, who continued to emulate the great seventeenth-century master into the next century. Although one would not mistake these reliefs for autograph works by Bernini, their marked Bernini-esque qualities, led Santangelo (1955, 375) to date them to the early seventeenth century and attribute them to Duquesnoy. Only after a careful study of the entire corpus of work produced by Mazzouli, was Pansecchi (1959, 33-43) able to identify the two reliefs in the Palazzo Venezia as by the Sienese sculptor.

These profile depictions of the Virgin and Angel were created as a pair. They are unified both by their style and by the event, the moment of the Annunciation, which their interaction narrates. Both reliefs are modeled with great sensitivity; the strong, clean lines of the facial features and the deep pockets of shadow emphasize the grace and beauty of the two heads. Their expressions are contemplative and restrained.

One has the impression that the Angel and Virgin are engaged in a genteel, quiet conversation, quite at odds with the more exuberant drama that Bernini would surely have depicted.

The subtle effect of light flickering across the differently finished surfaces of the marble recalls the work of Florentine Baroque sculptors, such as Foggini, who was also trained in Rome. Here again, one senses the dual source of Mazzouli's inspiration: the great example provided by Bernini is adjusted to conform to local, Tuscan taste.

More important, these two marble reliefs demonstrate the shifting concerns of sculptors of the generation following Bernini. They downplayed the dramatic, expressive content of Bernini's work, focusing instead on a dignified formality and a decorative, elegant surface. But they retained the extraordinary technical skills first introduced by the great master of the Roman Baroque. By the early eighteenth century, the emphasis on technical proficiency seems to have finally overwhelmed any traces of Bernini's expressive style.

MGB

Bibliography: Santangelo, 1955, 375; Pansecchi, 1959, 33-43; *In corso d'opera*, 1988, 33; Barberini, 1991, 61

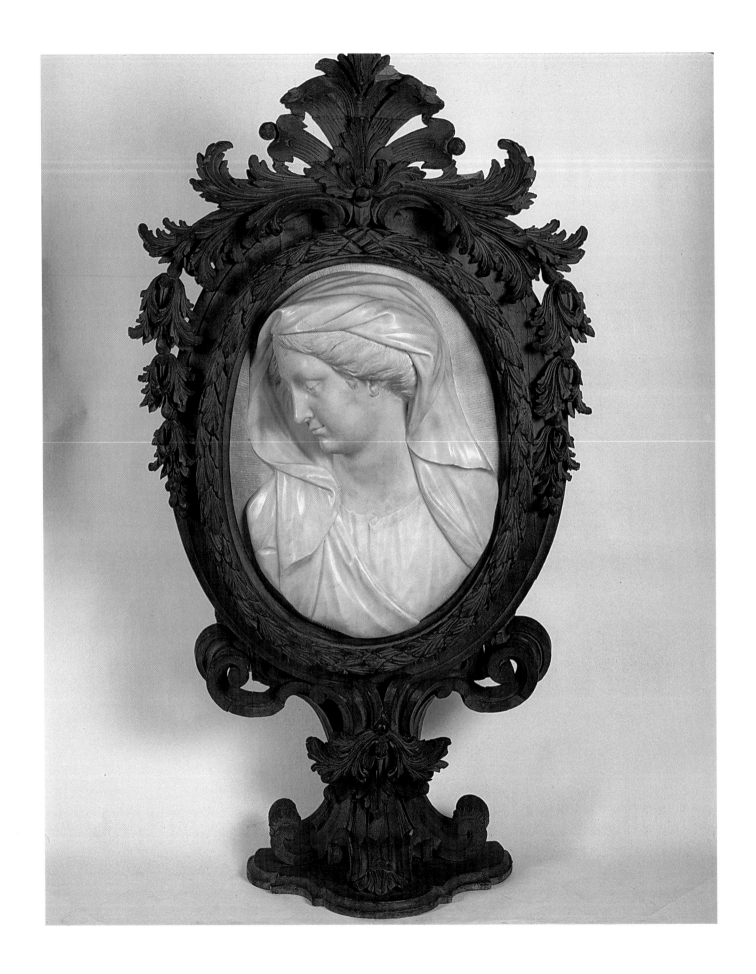

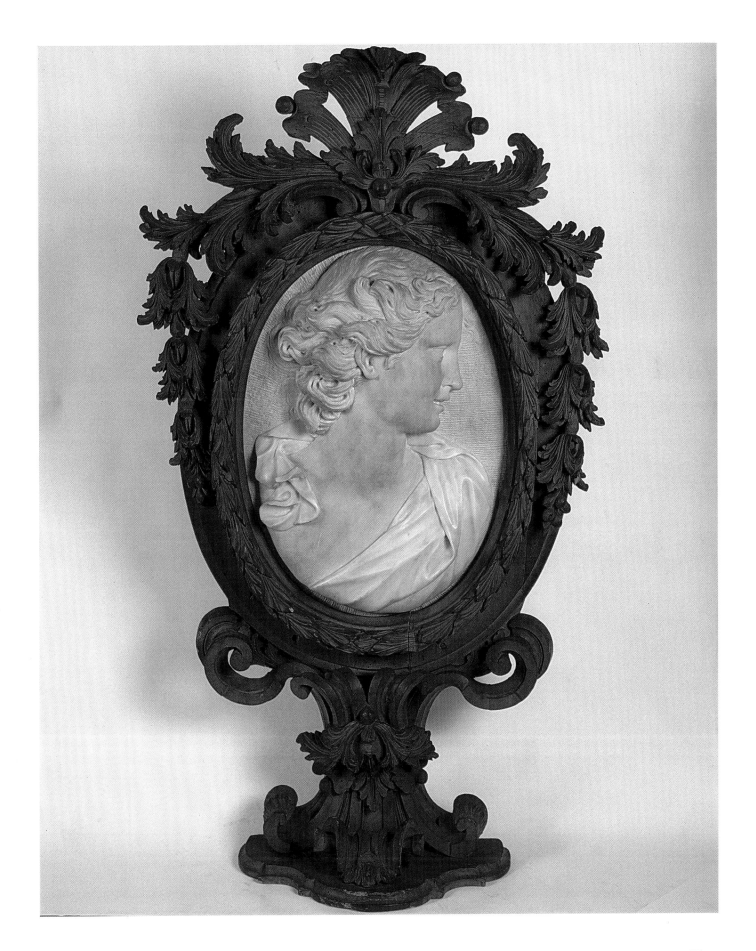

Bibliography

1506 *Epistolae et Commentarii Jacobi Piccolomini Cardinalis Papiensis*, Mediolani [Milan], 1506

1518 Fra Mariano da Firenze, *Itinerarium Urbis Romae (1518)* [Studi di Antichità Cristiana Pontificio Istituto di Archeologia Cristiana, II], intro. P. Enrico Bulletti, Rome, 1931

1565 *Epistolae D. Hieronymi Stridoniensis, et Libri, Contra Haereticos ex antiquissimis exemplaribus, mille e amplius mendis ex Eresmi correctione sublatis...*, ed. Maiano Vittori, Rome, 1565

BEFORE 1568 Onofrio Panvinio, 'Ecclesies Urbis Romae,' BAV, Vat. Lat. cod. 6781

1568 Giorgio Vasari, *Le vite de' più eccellenti pittori scultori ed architettori*, ed. Gaetano Milanesi, 9 vols., Florence, 1878-1885

1570 Onofrio Panvinio, *De praecipius urbis Romae sanctioribusque basilicis, quas septem ecclesias vulgo vocant Liber*, Rome, 1570 [printed in Italian as *Le sette chiese principali di Roma.*, trans. M.A. Lanfranchi, Rome, 1570]

1588 Pompeo Ugonio, *Historie delle stazioni di Roma*, Rome, 1588

1621 Paolo De Angelis, *Basilicae S. Mariae Maioris de Urbe a Liberio papa I usque ad Paulum V. Pont. Max*, Rome, 1621

CA. 1754 Giuseppe Bianchini, "Monumenti per la storia della basilica Liberiana," MSS T74-T95, Biblioteca Vallicelliana, Rome, T86, "Dissertazione del P. Giuseppe Bianchini sopra la translazione ed esistenza del Corpo di S. Girolamo nella Bas. Liberiana" [esp. two letters written to Bianchini in 1747 and 1749 - T86 no. 1: "Lettera di Pier Filippo Strozzi al P. Giuseppe Bianchini intorno al Corpo di S. Girolamo" and 2: Altra lettera del medesimo al P. Giuseppe Bianchini, sul medesimo argomento"]

1845 Filippo Baldinucci, *Notizie dei professori del disegno da Cimabue in qua*, ed. F. Ranalli, 4 vols., Florence, 1845-7 [vol. IV, 1846]

1878 Eugène Müntz, *Les Arts à la Cour des Papes pendant le XVe et le XVIe siècle*, 3 vols., Paris, 1878-1882 [vol. I, 1878; vol. III, 1882]

Eugène Müntz, "Inventaire des bronzes antiques de la collection du Pape Paul II (1457-1471)," *Revue Archéologique*, 1878, N.S., XXXVI, 87-92.

1888 Adolfo Venturi, "Bassorilievi di Mino da Fiesole," *Archivio storico dell'arte*, I, 1888, 411-413

1890 Domenico Gnoli, "Le opere di Mino da Fiesole in Roma, Parte II," *Archivio storico dell'arte*, III, 1890, 89-106

1892 Wilhelm Bode, *Denkmäler der Renaissance-Skulptur Toscanas*, 11 vols., Munich, 1892-1905

1893 Xavier Barbier de Montault, "Le culte des Docteurs de l'Eglise à Rome," *Revue de l'art chrétien*, XXVIII, 1893, 106-118

1897 Eugène Müntz, *La tiare pontificale du VIIIe au XVIe siècle*, Paris, 1897 [extract from *Mémoires de l'Académie des Inscriptions et Belles-Lettres*, XXXVI]

1901 Stanislao Fraschetti, "Una disfida artistica a Roma nel Quattrocento," *Emporium*, XIV, 1901, 101-116

Emanuele Rodocanachi, *Les Institutions Communales de Rome sous la Papauté*, Paris, 1901

1902 Rodolfo Lanciani, *Storia degli scavi di Roma. I. (1000-1530)*, Rome, 1902

1904 Diego Angeli, "I due Mino," *Nuova antologia*, Ser. IV, LXIII, 1904, 425-435

1905 Diego Angeli, *Mino da Fiesole*, Florence, 1905

1907 Wilhelm Bode, *Die italienischen Bronzestatuetten der Renaissance*, 2 vols., Berlin, 1907 [see Bode and Draper, 1980]

1908 Adolfo Venturi, *Storia dell'arte italiana. VI. La scultura del quattrocento*, Milan, 1908

1909 "Notizie: Musei e Gallerie," *Bolletino d'Arte*, III, 1909, 279

1911 *Mostra d'Arte retrospettiva in Castel Sant'Angelo*, exh. cat., Rome, 1911

1913 Alessandro Luzio, *La Galleria dei Gonzaga venduta all'Inghilterra nel 1627-28*, Milan, 1913

1915 Giovanni Biasiotti, "La basilica di S. Maria Maggiore di Roma prima delle innovazioni del secolo XVI," *Mélanges d'Archéologie et d'Histoire*, XXXV, 1915, 15-40

Jean Marx, "Quatres Documents relatifs à Guillaume d'Estouteville," *Mélanges d'Archéologie et d'Histoire*, XXXV, 1915, 41-55

1918 Jean Alazard, "Mino da Fiesole à Rome, *Gazette des Beaux-Arts*, XIV, 1918, 75-88

1920 Giovanni Biasiotti, "Le memorie di S. Girolamo in Santa Maria Maggiore di Roma," *Miscellanea Geronimiana*.

Scritti varii: pubblicati nel XV centenario della morte di San Girolamo, Rome, 1920, 237-244

1921 Francesco Lanzoni, "Il Sepolcro di S. Girolamo," *La Scuola Cattolica*, XLIX, 1921, 383-390, 458-469

1922 Lodovico Pollak, *Raccolta Alfredo Barsanti. Bronzi italiani*, Rome, 1922

1923 Albert Erich Brinckmann, *Barock-Bozzetti. Italienische Bildhauer/Italian Sculptors*, 2 vols., Frankfurt am Main, 1923-1926

1925 Carlo Galassi Pauzzi, "Un bozzetto di Alessandro Algardi per l'urna di S. Ignazio al Gesù," *Roma*, III, 1925, 17-18

1928 Hildegard Lange, *Mino da Fiesole. Ein Beitrag zur Geschichte der florentinischen und römischen Plastik des Quattrocento*, Inaugural Dissertation, Ludwig-Maximilians-Universität zu München, Greifwald, 1928

1929 Valerio Mariani, "Bozzetti berniniani," *Bollettino d'arte*, IX, 1929-30, 59-65

1930 Valerio Mariani, "Note berniniane," *Bollettino d'arte*, X, 1930-31, 57-69

Frida Schottmüller, "Mino da Fiesole," in *Thieme-Becker*, XXIV, Leipzig, 1930, 580-582

1931 Heinrich Brauer and Rudolf Wittkower, *Die Zeichnungen des Gianlorenzo Bernini* [Römische Forschungen der Bibliotheca Hertziana, IX-X], Berlin, 1931

Leo Planiscig, "Collezione G. Auriti. Bronzi e targhette. Vienna, 1931," [handwritten ms in the collection of the Museo Nazionale del Palazzo di Venezia, Rome]

1933 Luigi Serra, "Il riordinamento del R. Museo Artistico Industriale di Roma," *Bollettino d'arte*, XXVII, 1933-1934, 573-583

1935 Vincenzo Golzio, "Lo 'studio' di Ercole Ferrata," *Archivi*, II, 1935, 64-74

1936 S.A. Callisen, "A Bust of a Prelate in the Metropolitan Museum of Art, New York," *Art Bulletin*, XVIII, 1936, 401-406

1938 Carlo L. Ragghianti, "La mostra di scultura italiana antica a Detroit (U.S.A.)," *Critica d'arte*, III, 1938, 170-83

1940 Marcello Piacentini, "L'epistolario di Leonardo Agostini e due notizie sul Bernini," *Archivi*, Ser. II, VII, 1940, 71-80

1942 Alberto Riccoboni, *Roma nell'arte. La scultura nell'evo moderno dal quattrocento ad oggi*, Rome, 1942

1944 Wilhelm R. Valentiner, "Mino da Fiesole," *Art Quarterly*, VII, 1944, 150-180 [reprinted in idem, *Studies in Italian Renaissance Sculpture*, London and New York, 1950, 70-96]

1945 R. Langton Douglas, "Mino del Reame," *Burlington Magazine*, LXXXVII, 1945, 217-224

1946 Luigi Grassi, "Disegni inediti del Bernini e la decorazione di ponte S. Angelo," *Arti figurative*, II, 1946, 186-199

1948 Frederico Hermanin, *Il Palazzo di Venezia*, Rome, 1948

Antonino Santangelo, *Museo di Palazzo Venezia. Catalogo I. Dipinti*, Rome, 1948

Charles de Tolnay, *Michelangelo, III - The Medici Chapel*, Princeton, 1948

1954 Antonino Santangelo, *Museo di Palazzo Venezia. Catalogo delle sculture*, Rome, 1954

1955 Valentino Martinelli, "I busti berniniani di Paolo V, Gregorio XV e Clemente X," *Studi romani*, III, no. 6, 1955, 647-666

Antonino Santangelo, "Francesco Du Quesnoy: 'La Vergine e l'Infante,'" *Bollettino d'arte*, XL, 1955, 375

Rudolf Wittkower, *Gian Lorenzo Bernini, The Sculptor of the Roman Baroque*, London, 1955 [2nd ed., 1966; Italian ed., 1990]

1956 Elisabeth Dhanens, *Jean Boulogne, Giovanni Bologna Fiammingo*, Brussels, 1956

Irving Lavin, "Review of Rudolf Wittkower, 'The Sculptures of Gian Lorenzo Bernini'," *Art Bulletin*, XXXVIII, 1956, 255-260

Valentino Martinelli, *I ritratti di Pontefici di G.L. Bernini*, Rome, 1956

Valentino Martinelli, "La scultura in Italia," *Il seicento Europeo, realismo, classicismo barocco*, exh. cat., Palazzo delle Esposizione, Rome, 1956-1957, 51-59

Antonia Nava Cellini, "Contributi a Melchior Caffà," *Paragone*, VII, no. 83, 1956, 17-31

1957 Cesare D'Onofrio, *Le fontane di Roma con documenti e disegni inediti*, Rome, 1957

Luigi Grassi, *I concetti di schizzo, abbozzo, macchia, non finito e la costruzione dell'opera d'arte* [extract from the studies in honor of Pietro Silva], Florence, 1957

1958 Lamberto Donati, "Le fonti iconografiche di alcuni manoscritti urbinati della Biblioteca Vaticana," *La Bibliofilia*, LX, 1958, 48-129

Roberto Weiss, *Un umanista veneziano, Papa Paolo II*, Venice and Rome, 1958

Italo Faldi, *La scultura barocca in Italia*, Milan, 1958

1959 Fiorella Pansecchi, "Contributi a Giuseppe Mazzuoli," *Commentari*, X, 1959, 33-43

Helen Roberts, "St. Augustine in 'St. Jerome's Study': Carpaccio's Painting and its Legendary Source," *Art Bulletin*, XLI, 1959, 283-303

1961 *Italian Bronze Statuettes,* exh. cat., Victoria and Albert Museum, London, 1961

Klaus Schwager, "Zur Bautätigkeit Sixtus V. an S. Maria Maggiore in Rom," *Miscellanea Bibliothecae Hertzianae. Zu Ehren von Leo Bruhns, Franz Graf Wolff Metternich, Ludwig Schudt*, Munich, 1961, 324-354

1962 Pico Cellini, "L'opera di Arnolfo all'Aracoeli," *Bollettino d'arte*, Ser. IV, XLVII, 1962, 180-195

Luigi Grassi, *Gianlorenzo Bernini*, Rome, 1962

1963 John Pope-Hennessy, "Italian Bronze Statuettes," *Burlington Magazine*, CV, 1963, 14-23, 58-71 [reprinted in idem, *Essays on Italian Sculpture*, London and New York, 1968, 172-198]

1964 Antonino Santangelo, *Museo di Palazzo Venezia. La Collezione Auriti*, Rome, 1964

1965 *Art in Italy, 1600-1700*, exh. cat., Detroit Institute of Arts, Detroit, 1965

1966 Charles Seymour Jr., *Sculpture in Italy: 1400-1500* [The Pelican History of Art], Harmondsworth, 1966

Rudolf Wittkower, *Gian Lorenzo Bernini: The Sculptor of the Roman Baroque*, 2nd ed., London, 1966

1967 Maurizio Fagiolo dell'Arco and Marcello Fagiolo dell'Arco, *Bernini. Una introduzione al gran teatro del barocco*, Rome, 1967

Irving Lavin, "Bozzetti and Modelli, Notes on Sculptural Procedure from the Early Renaissance through Bernini," *Stil und Uberlieferung in der Kunst der Abendlandes* [Aktes des 21. Internationalen Kongresses für Kunstgeschichte in Bonn, 1964], 3 vols. Berlin, 1967, III, 93-104

1968 Irving Lavin, "Five Youthful Sculptures by Gianlorenzo Bernini and a Revised Chronology of His Early Works," *Art Bulletin*, L, 1968, 223-248

1968 Paul Antin, "L'apparition de S. Jérôme et de S. Jean Baptiste à S. Augustin par Mino da Fiesole," *Recueil sur St. Jérôme*, Bruxelles, 1968, 23-26

Vincenzo Golzio and Giuseppe Zander, *L'arte in Roma nel secolo XV* [Storia di Roma, XXVIII], Bologna, 1968

Hanno-Walter Kruft and Lars Olof Larsson, "Porträtzeichnungen Berninis und seiner Werkstatt," *Pantheon*, XXVI, 1968, 130-135

Udo Kultermann, *Gabriel Grupello*, Berlin, 1968

Gianni Carlo Sciolla, *La scultura di Mino da Fiesole*, Turin, 1970

1969 Rudolf Preimesberger, "Ein Bozzetto Melchiorre Cafas," *Wiener Jahrbuch für Kunstgeschichte*, XXII, 1969, 178-183

1971 Mark S. Weil, "The Angels of the Ponte Sant'Angelo: A Comparison of Bernini's Sculpture to the Work of Two Collaborators," *Art Journal*, XXX, 1971, 252-259

1972 Henri Focillon, *Vita delle forme*, Turin, 1972

1973 Charles Avery, "Hendrick de Keyser as a Sculptor of Small Bronzes: His Orpheus and Cerberus Identified," *Bulletin van het Rijksmuseum*, XXI, 1973, 3-24 [reprinted in idem, *Studies in European Sculpture*, London, 1981, 175-188]

A.J. Dunston, "Pope Paul II and the Humanists," *Journal of Religious History*, VII, no. 4, 1973, 287-306

Minna Heimbürger Ravalli, *Alessandro Algardi scultore*, Rome, 1973

Rudolf Preimesberger, "Melchiorre Cafà," in *Dizionario Biografico degli Italiani*, XVI, Rome, 1973, 230-235

Katherine Watson and Charles Avery, "Medici and Stuart: a Grand Ducal Gift of 'Giovanni Bologna' Bronzes for Henry Prince of Wales (1612)," *Burlington Magazine*, CXV, 1973, 493-507 [reprinted in Charles Avery, *Studies in European Sculpture*, London, 1981, 95-113]

Rudolf Wittkower, *Art and Architecture in Italy, 1600-1750* [The Pelican History of Art], 3rd revised ed., Harmondsworth, 1973

1974 H. Lee Bimm, "Bernini's Papal Portraiture: A Medallion and a Missing Bust," *Paragone*, XXV, no. 293, 1974, 72-76

Silvana De Caro Balbi, "Gian Lorenzo Bernini e la medaglia barocco romano," *Medaglia*, IV, no. 7, 1974, 7-26

Mark Weil, *The History and Decoration of the Ponte S. Angelo*, University Park, PA, and London, 1974

Rudolf Wittkower, *The Sculptor's Workshop. Tradition and Theory from the Renaissance to the Present* [W.A. Cargill Memorial Lectures in Fine Art, 3], Glasgow, 1974

1975 Massimo Miglio, *Storiografia pontificia del Quattrocento*, Bologna, 1975

1976 Bruno Bearzi, "La tecnica della scultura nel Vasari," *Il Vasari storiografico e artista* [Atti del congresso internazionale nel IV centenario della morte, Arezzo-Firenze, 2-8 settembre, 1974], Florence, 1976, 27-33

Ulrich Middeldorf, *Sculpture from the Samuel H. Kress Collection. European Schools, XIV-XIX Century*, London, 1976

1977 Laura Gigli, *S. Marcello al Corso* [Le chiese di Roma illustrate, 128], Rome, 1977

Minna Heimbürger Ravalli, *Architettura, scultura e arti minori nel barocco italiano. Ricerche nell'Archivio Spada*, Florence, 1977

Rudolf Wittkower, *Sculpture: Processes and Principles*, New York, 1977

1978 Charles Avery, "Giambologna's sketch-models and his sculptural technique," *Connoisseur*, CIC, no. 799, 1978, 3-11

Charles Avery and Anthony Radcliffe, eds., *Giambologna 1529-1608. Sculptor to the Medici*, exh. cat., Royal Scottish Museum, Edinburgh; Victoria and Albert Museum, London, 1978

Irving Lavin, "Calculated spontaneity. Bernini and the terracotta sketch," *Apollo*, CVII, no. 195, 1978, 398-405

Ursula Schlegel, *Die italienischen Bildwerke des 17. und 18. Jahrhunderts in Stein, Holz, Wachs und Bronze* [Die Bildwerke der Skulpturengalerie Berlin, I, Staatliche Museen preussischer Kulturbesitz], Berlin, 1978

Phoebe Dent Weil, ed., *Orfeo Boselli, Osservationi della scultura antica dai manoscritti Corsini e Doria*, Florence, 1978

1980 Wilhelm Bode, *The Italian Bronze Statuettes of the Renaissance*, ed. James D. Draper, New York, 1980 [reprint of 1908 edition]

Nicole Dacos et al., *Il tesoro di Lorenzo il Magnifico*, Florence, 1980

Irving Lavin, *Bernini and the Unity of the Visual Arts*, 2 vols., New York and London, 1980

1981 Cesare D'Onofrio, *Gian Lorenzo Bernini e gli angeli di ponte Sant'Angelo. Storia di un ponte*, Rome, 1981

Irving Lavin, *Drawings by Gianlorenzo Bernini from the Museum der Bildenden Künste, Leipzig*, exh. cat., Princeton University Art Museum, Princeton, 1981

1982 Pietro Cannata, *Rilievi e placchette dal XV al XVIII secolo*, Rome, 1982

Michael P. Mezzatesta, *The Art of Gianlorenzo Bernini. Selected Sculpture*, exh. cat., Kimball Art Museum, Fort Worth, 1982

Antonia Nava Cellini, *La scultura del seicento*, Turin, 1982

Paolo Prodi, *Il sovrano pontefice*, Bologna, 1982

1983 Paolo Cherubini, "Giacomo Ammannati Piccolomini: libri, biblioteca e umanisti," *Scrittura, bibliotheche e stampa a Roma nel quattrocento* [Atti del II seminario, 6-8 maggio, 1982], ed. Massimo Miglio, Vatican City, 1983, 175-256

Penny Howell Jolly, "Antonello da Messina's 'St. Jerome in His Study': An Iconographic Analysis," *Art Bulletin*, LXV, 1983, 238-253

1984 Charles Avery, "'La Cera sempre aspetta': Wax Sketch-Models for Sculpture, *Apollo*, CXIX, no. 265, 1984, 166-176

Pietro Cannata, "G.L. Bernini, Clemente X," *Roma 1300-1875: l'arte degli anni santi*, eds. M. Fagiolo and M.L. Madonna, exh. cat., Palazzo Venezia, Rome, Milan, 1984, 438-439, X.28

Giuseppe Zander, "Considerazione su un tipo di ciborio in uso a Roma nel Rinascimento," *Bollettino d'arte*, LXIX, no. 26, 1984, 99-106

1985 Jennifer Montagu, *Alessandro Algardi*, 2 vols., New Haven and London, 1985

Jennifer Montagu, "Bernini Sculptures Not by Bernini," *Gianlorenzo Bernini; New Aspects of His Art and Thought*, ed. Irving Lavin, University Park, PA and London, 1985, 25-43

John Pope-Hennessy, *Italian Renaissance Sculpture*, 3rd. ed., New York, 1985

Eugene F. Rice, Jr., *St. Jerome in the Renaissance*, Baltimore and London, 1985

Shelley Zuraw, "Mino da Fiesole," *Italian Renaissance Sculpture in the Time of Donatello*, exh. cat., Detroit Institute of Arts, Detroit, 1985, 185-189

1986 Paolo Brezzi, "La funzione di Roma nell'Italia della seconda metà del '400," *Un pontificato ed una città. Sisto IV (1471-1484)* [Atti del convegno, 3-7 dicembre, 1984], ed. Massimo Miglio et al., Vatican City, 1986, 1-18

Jennifer Montagu, "Disegni, Bozzetti, Legnetti and Modelli in Roman Seicento Sculpture," *Entwurf und Ausführung in der europäischen Barockplastik* [Beiträge zum internationalen Kolloquium des Bayerischen Nationalmuseum und des Zentralinstituts für Kunstgeschichte Munich, 1985], Munich, 1986, 9-30

John Pope-Hennessy, *Italian High Renaissance and Baroque Sculpture*, 3rd. ed., London, 1986

1987 Charles Avery, *Giambologna. The Complete Sculpture*, Oxford, 1987. [Italian ed., *Giambologna, La scultura*, Florence 1987]

Francesco Caglioti, "Per il recupero della giovinezza romana di Mino da Fiesole: il 'Ciborio della neve'," *Prospettiva*, 1987, no. 49, 15-32

Elena Bianca Di Gioia, "Un bronzetto della Santa Rosa da Lima di Melchiorre Caffà nel Museo di Roma," *Bollettino dei musei comunali di Roma*, N.S. I, 1987, 39-53

Peter Fusco and Scott Schaefer, *European Painting and Sculpture in the Los Angeles County Museum of Art*, Los Angeles, 1987

Giovanni Mariacher, *La scultura del cinquecento*, Turin, 1987

Steven F. Ostrow, "The Sistine Chapel at S. Maria Maggiore: Sixtus V and the Art of the Counter Reformation," Ph.D. dissertation, Princeton University, 1987

1988 Maria Giulia Barberini, *Laboratori di Restauro 2*, exh. cat., Palazzo Venezia, Rome, 1988

Pietro Cannata, "La Collezione Barsanti, la Collezione Auriti, la Collezione Ravajoli," *Soprintendenza per i beni artistici e storici di Roma. Museo Nazionale di Palazzo Venezia*, Rome, 1988, 21-23

Enrico Comastri, "Profilo di Giulio dal Moro," *Arte veneta*, XLII, 1988, 87-97

Elena Bianca Di Gioia, "Le insegne dell'Ospizio Apostolico dei Poveri Invalidi," *Le immagini del Ss. Salvatore. Fabbriche e sculture per l'Ospizio Apostolico dei Poveri Invalidi*, exh. cat., Castel Sant'Angelo, Rome, 1988, 285-334

Fabrizio Mancinelli, "La basilica nel Quattrocento," *Santa Maria Maggiore a Roma*, ed. Carlo Pietrangeli, Florence, 1988, 191-214

Helga Tratz, "Werkstatt und Arbeitsweise Berninis," *Römisches Jahrbuch für Kunstgeschichte*, XXIII/XXIV, 1988, 395-483

In corso d'opera: situazione e progetti, exh. cat., Palazzo Venezia, Rome, 1988

Luisa Cardilli Alloisi and Maria Grazia Tolomeo Speranza, *La via degli angeli: il restauro della decorazione scultorea di Ponte Sant'Angelo*, Rome, 1988

1989 Jennifer Montagu, *Roman Baroque Sculpture: The Industry of Art*, New Haven and London, 1989

Sergej Androsov, *Terracotte italiane dei secoli XVII-XVIII dalla collezione dell'Hermitage*, exh. cat., Hermitage, Leningrad, 1989 [in Russian]

Bruni Contardi, "Melchiorre Caffà," *Due terracotte romane del Seicento*, exh. cat., Castel Sant'Angelo, Rome, 1989, 25-33

1990 Evonne Levy, "'A Noble Medley and Concert of Materials and Artifice.' Jesuit Church Interiors in Rome, 1567-1700," *Saint, Site, and Sacred Strategy. Ignatius, Rome, and Jesuit Urbanism*, ed. Thomas M. Lucas, Vatican City, 1990, 46-61

Joachim Poeschke, *Die Skulptur der Renaissance in Italien. Donatello und seine Zeit*, Munich, 1990

Rudolf Wittkower, *Bernini, Lo scultore del Barocco romano*, Milan, 1990 [Italian translation and new edition]

Gerhard Wolf, *Salus populi romani: die Geschichte römischer Kultbilder im Mittelalter*, Weinheim, 1990

1991 Maria Giulia Barberini, *Scultura in terracotta del barocco romano: bozzetti e modelli del Museo Nazionale del Palazzo di Venezia*, exh. cat., Palazzo Venezia, Rome, 1991-1992

Francesco Caglioti, "Mino da Fiesole, Mino del Reame, Mino da Montemignaio: un caso chiarito di sdoppiamento d'identità artistica," *Bollettino d'arte*, LXXVI, no. 67, 1991, 19-86

Sergej O. Androsov, *Alle origini di Canova: le terracotte della collezione Farsetti*, exh. cat., Rome, Fondazione Memmo, Venice, 1991

1992 Maria Letizia Casanova, *Il Palazzo Venezia*, Rome, 1992

Meredith Gill, "A French Maecenas in the Roman Quattrocento: The patronage of Cardinal Guillaume d'Estouteville (1479-1483)," Ph.D. dissertation, Princeton University, 1992

Shelley Zuraw, "Mino da Fiesole's First Roman Sojourn," *Verrocchio and Late Quattrocento Italian Sculpture*, eds. Steven Bule et al., Florence, 1992, 303-320

1993 Shelley Zuraw, "The Sculpture of Mino da Fiesole (1429-1484)," Ph.D. dissertation, Institute of Fine Arts, New York University, 1993

1994 Francesco Negri Arnoldi, *La scultura del quattrocento*, Turin, 1994

Maria Giulia Barberini and Carlo Gasparri, *Bartolomeo Cavaceppi: scultore romano (1717-1799)*, exh. cat., Palazzo Venezia, Rome, 1994

William E. Wallace, *Michelangelo at San Lorenzo; The Genius as Entrepreneur*, Cambridge, 1994

1995 G. Florez Araoz-Ramon, Pinilla-Luis Eduardo Wuffarden, and Pedro Perez, *Santa Rosa de Lima y su tiempo*, Lima, 1995

1996 Jennifer Montagu, *Gold, Silver and Bronze; Metal Sculpture of the Roman Baroque*, Princeton, 1996

Credits

ORGANIZERS OF THE EXHIBITION:

Soprintendenza per i Beni Artistici e Storici, Roma
Soprintendente, Prof. Claudio Massimo Strinati

Museo Nazionale del Palazzo di Venezia, Roma
Direttore, Dott.ssa Maria Letizia Casanova

Georgia Museum of Art, Athens
Director, Dr. William U. Eiland

CATALOGUE ENTRIES WERE WRITTEN BY:

MGB Dott.ssa Maria Giulia Barberini
PC Dott. Pietro Cannata
SEZ Prof. Shelley E. Zuraw

WE WOULD LIKE TO ACKNOWLEDGE:

IN ROME

COORDINATOR: Dott.ssa Silvana Grosso

RESTORATIONS: Laboratorio di restauro Soprintendenza per
i Beni Artistici e Storici,
Silvano Germoni, Mina Passalacqua

PHOTOGRAPHS: Laboratorio fotografico Soprintendenza per
i Beni Artistici e Storici,
Annino Loretelli, Gianni Cortellessa, Gianfranco Zecca
Stefano Fabi, Maurizia Mancini

Archivio Fotografico Soprintendenza:
Giorgio Guarnieri, Lisa Di Giacomo, Cosimo Chiarelli

SECRETARY, MUSEO DI PALAZZO VENEZIA:
Maria Grazia Marcucci

SECRETARIES, SOPRINTENDENZA:
Giuseppina Bioicati, Carmela Crisafulli, Gennaro Aliperta

IN ADDITION, WE WOULD LIKE TO THANK:
Maria Grazia Bernardini, Director, Gabinetto Restauro
Soprintendenza

Anna Lo Bianco, Director, Gabinetto Fotografico
Soprintendenza

IN ATHENS

SECRETARY TO THE DIRECTOR, GEORGIA MUSEUM OF ART:
Peggy Sorrells

PREPARATORS, GEORGIA MUSEUM OF ART:
Jim StipeMass, Gregory Benson

REGISTRARS, GEORGIA MUSEUM OF ART:
Lynne Perdue, Annelies Mondi, Patricia Wright, Danielle
Gunter, Allison Patch

PUBLICATIONS AND PUBLIC RELATIONS,
GEORGIA MUSEUM OF ART:
Bonnie Ramsey, Wendy Cooper, Jennifer DePrima

CURATOR OF EDUCATION:
Victoria Lepka

DOCENT PROGRAMS, GEORGIA MUSEUM OF ART:
Gail Bridges, Trudy Snyder

OFFICE MANAGER, GEORGIA MUSEUM OF ART:
Vicky Brown

ASSISTANT FOR DEVELOPMENT, GEORGIA MUSEUM OF ART:
Betty Alice Fowler

SECURITY STAFF, GEORGIA MUSEUM OF ART:
Tammy Evans, Barbara Free

SECRETARY, FRIENDS OF THE GEORGIA MUSEUM OF ART:
Lanie Lessard

GRAPHIC DESIGN AND PRODUCTION:
Kudzu Graphics, Athens
(Ron Evans, Barry Stock)

TRANSLATIONS:
Jody Shiffman, Andrew Ladis, Shelley Zuraw